The Sopranos: Season Seven
"It ain't over till the fat Soprano croaks."

by

Maurice Yacowar

Professor Emeritus, University of Calgary

Author of *The Sopranos on the Couch* (Continuum)

ISBN 978-1-4357-0509-8
Copyright the author 2007

Introduction

I got hooked by *The Sopranos* when I watched the first episode and I stayed hooked. As the drama unfolded I wrote an episode-by-episode analysis of the show's first three seasons—*The Sopranos on the Couch*. My publisher, Continuum Books, generously brought out new editions to cover Seasons Four, Five and then Six. My present offering is a supplement to that last edition, my analysis of the show's last season. The analyses – and the Season Seven cast list that follows it – should be read as a supplement to that last, "Ultimate" edition.

As a bonus I've added three Appendices: (i) the influence of William Wellman's *Public Enemy* (1931) on *The Sopranos*; (ii) the issue of Italian-American Stereotypy, and (iii) the mysterious recurrence of oranges in the *Godfather* trilogy.

I know, HBO (and presumably David Chase) have declared that the last nine episodes – which I am discussing here – are really the conclusion to Season Six. I'm calling them Season Seven because they were presented as a separate unit, after the familiar tantalizing delay, and with their own discrete structure.

So? Whadyagonnado?

Season Seven

My story so far. In *The Sopranos on the Couch* I proposed that the drama was a five-act/season examination of the dangerous charm of Evil. It centered on whether Carmela could escape Tony's soul-destroying grip, as Charmaine did. By falling in love with Carmela Furio transcends his violence and escapes Tony. Carmela breaks free from Tony not through her mid-drama (III, 7) therapist's moral advice but out of marital humiliation. But at the end of Season Five her love for material comfort has returned her to Tony's thrall.

In the two-part/season conclusion the focus shifts back to Tony. In Season Six his near-death experience provokes a new sense of harmony with the world, a conscience, a spiritual awakening. Because he loses all that by season end the last nine episodes (Season Seven) trace the disintegration of Tony's world. One by one his enemies and his friends fall, until the very last scene claims Tony, too. Or does it? By then, does it matter?

VII,1 Soprano Home Movies

Written by Diane Frolov & Andrew Schneider and David Chase & Matthew Weiner. Directed by Tim Van Patten.

The Essex County police arrest Tony for the hollow-point pistol a teenage boy found after Tony fled Johnny Sack's arrest (V, 13). The Feds have the charge dropped, then renew it to bolster their planned RICO case. A weekend at the Baccalieris' lakeside retreat turns into a drunken brawl where Bobby bests Tony. In a deal to traffic in expired pharmaceuticals, Tony has Bobby whack a Quebec crook's ex-brother-in-law to solve a custody suit.

<center>***</center>

For his 47th birthday Janice gives Tony a DVD of their family's old Super-8 movies, where Tony chases little Janice after she has hosed him. In Janice's metaphoric gift, the new medium replays the old family battles. Like the banned hollow-point bullet, the emptiness in the family makes it more lethal. Carmela gives him posh golf clubs and a blow job and Bobby gives him an AR-10 automatic machine gun with which he prunes the trees. That detail proves Tony's lapse from his Season VI harmony with Nature.

The dominant theme is the fragility of the family's comfort and security. At the police's 6 a.m. pound on the door Carmela's "Is this it?" suggests she expects *The Sopranos'* end. Like the Quebeckers'

osteoporosis pills, the characters near the end of their shelf life. But they don't have the drugs' delusion: "Change the date, nobody knows." Tony wants to downplay his birthday. "I'm old, Carmela," and his body won't ever fully recover from its Season Six trauma. In jail his future seems limned in the black man on the toilet behind him. The off-and-on weapon charge confirms his insecurity. Enjoying his little niece, Tony is haunted by the story of a child left brain dead after falling into a pool surrounded by partying adults.

Janice's new peace with Tony cracks with her dig about her lost gardener (the exploited Sal) and her implying only Tony has had to change. She angers Tony wih her story of their father shooting Livia in her beehive hairdo. To Tony the story "makes us look like a fucking dysfunctional family. Jesus Christ." With little Nika, Janice's loving motherliness crumbles into anger, profanity and an unreasonable punishment when she has her packed off to bed for refusing to leave the water. Janice replays Livia's anger at her child's first assertion of independence: "When they started to talk and express ideas that's when the trouble started." Janice echoes Livia when she coaxes Tony and Carmela to stay for her breakfast frittata: "It's a sin to waste food."

Tony's fight with Bobby concentrates the theme. At first as Tony wallows in the setting's bliss, he confides in Bobby his dread: "Historically? Eighty per cent of the time it ends in the can, like Johnny Sack. Either that or on the embalming table at Cozarelli's." Tony is disappointed in Chris, their "diversion agendas." Tony hangs up on his belated birthday call. So Tony considers making Bobby his heir and gives him the projects window replacement scam.

That fraternal trust crumbles over the family's drunken Monopoly. To Dave Brubeck's *Take Five* Tony skims $500 from the bank. This alternative to karaoke, how he performs to the music, shows Tony perverting an innocent instruction. In the Sopranos' rules, whoever lands on a parking space plunders the Community Chest. As Bobby objects to this liberty – "You know, the Parker Brothers took time to think this all out. I think we should respect that."—he also rejects Tony's obscene insults to Janice. When Tony hums his version of The Drifters, "Under the boardwalk, with your *schlong* [Yiddish penis] in Jan's mouth" Bobby explodes with a punch and attack. Here Bobby becomes a Soprano: "You Sopranos – you go too far."

At 4 a.m. Tony rises to assure Bobby "You beat me fair and square," but he can't live with that. He tells Carmela he would have won had the fight happened before his surgery, had he not slipped on the throw rug, if Bobby weren't four years younger, if he hadn't taken

him by surprise. Tony can't give up the brute force with which he first caught Carmela's eye in high school. After their own camaraderie Janice and Carmela spar over their husbands' fight.

In revenge Tony assails Bobby's –relative—purity. In their karaoke Janice sings to her "old-fashioned baby," The Rolling Stones's *Out of Time* (Carmela: Nazareth's "Love hurts"). The amiable lug is appalled by Tony's suggestion he might hunt deer with a machine gun: "That's unsportsmanlike." To level the field he uses a bow and arrow. Though his father was a famed hit man, Bobby has never killed anyone. Tony's phrase evokes the drama's gender paradoxes: "You never popped your cherry in that regard." Maliciously, Tony spoils Bobby's innocence by having him kill the Quebec drummer: "No bow and arrows now." The order shows Bobby naïve when he assures Tony, the morning after the brawl, "We had a little too much to drink. But no harm done. The whole thing's already forgotten." Carmela is also wrong about her Tony: "He's not a vindictive man." Staring steely out on the water Tony has lost the harmony with the wind, trees and waters that he felt after his hospitalization (Season Six). Instead he grabs cues for crime and malice.

In the episode's last shot Bobby, back from his kill, cradles his little daughter as he looks out on the serene lake. Across the end credits falls the valedictory shadow of Ben E. King singing The Drifters' *This Magic Moment* (1960). The song encapsulates the episode's sense that life's joys feel magical because they are so fugitive. As The Drifters represent the lost innocence of Tony's generation – and the re-start of his erotic and violent brutishness—Tony's obscenity (*Under the Boardwalk*) is a broader offense than just to Bobby's wife.

The instability extends beyond the central characters. The 66-year-old Phil Leotardo, whose Welcome Home sign first seems addressed to Tony, emerges from his heart attack with Tony's lost sense of new life: "I'm here to enjoy my grandchildren, my family." He is disturbed by his colleagues' gleeful report of Tony's arrest. The Crests' *Trouble in Paradise* playing in the background summarizes the episode.

AJ continues his promising relationship with Blanca and her little son, the sight of which emcourages Tony to weekend with the Baccalieris. But AJ is still unreliable, bringing the jailed Tony soiled pants and skipping his pizza job to have a party in his parents' house and sex in their bed – also betraying Blanca. Carmela is pleased with Meadow's plans to be a pediatrician, though radiologists earn more.

For all her advanced moral sense, Meadow runs to her freed father's hug the way little Nika runs to Bobby, home from his kill.

The theme also expresses America's insecurity. Paulie announces Tony's return from jail as if he were the US soldiers back from Iraq or Afghanistan: "Take the yellow ribbons down, everybody. Our boy's come home." When Bobby recalls his grandfather's illegal entry from Montreal, when he was banned as anti-government, he appreciates the benefit of the loose border. But "They ought to build a wall now, though, I'm telling you." The others agree. Radio news reports a bloody suicide bombing in Iraq. For both the characters and the culture the momentary comfort betrays an ineluctable insecurity.

VII, 2 Stage 5

Written by Terence Winter. Directed by Alan Taylor.

Johnny Sack visibly declines from cancer then dies, leaving a vacuum in the New York Family leadership. Phil Leotardo and Carmine Jr both reject Tony's encouragement because they now put their family ahead of The Family. Tony enjoys Christopher's movie *Cleaver* but picks up Carmela's concern that it reflects Christopher's suspicion Tony seduced Adriana.

The center does not hold. Things continue to fall apart. Cleveland specialist Dr. Rosen tells Johnny Sack he has Stage 4 lung cancer, and Johnny knows, "there is no Stage 5." Even the optimistic diagnosis by orderly Warren Feldman—a qualified oncologist jailed for murdering his unfaithful wife, her aunt and the mailman—submits to the aggressiveness of Johnny's tumour.

So the men want to leave a legacy. Johnny Sack wonders how the street will remember him. Tony is proud that Christopher has completed his film—despite the opposition from the Elridge Cleaver estate: "You made a movie, Christopher. No matter what, they can't take that away." His new daughter is another investment in the future. Carmine Junior's wife doesn't want to be left the wealthiest widow in Long Island so he quits The Family. Phil Leotardo tries to teach his family's children about their noble past, despite the Ellis Island reduction of his family's name from the venerable Leonardo to ballet tights. With two offers on her spec house Carmela confirms her illusory independence. Christopher's film removes him from his Family duties. He forces his screenwriter JT to tell Tony that he not Chris thought up

the boss's seduction of his friend's fiancée. JT claims he based the boss on Broderick Crawford in *Born Yesterday* (George Cukor, 1950), but from JT's headwound Tony infers Chris's responsibility both for the scene and for this coverup. Tellingly, Carmela is not bothered by the film's representation of Tony as a brutish killer, only as the adulterer. Christopher is indignant when she confronts him. Opening the episode with a bloody scene from *Cleaver* establishes the inextricability of fiction from the life which feeds it – and in the shadow of *The Godfather*, vice-versa. So, too, the FBI arrests Larry Boy Barese for breaking his home parole by attending the post-premiere party. After Daniel Baldwin plays the Tony figure, Tony offers to "fix" his charge of driving with a broken windshield.

In the family's "Poor me" stance, Tony complains to Melfi that the cousin whom he so lovingly mentored now hates him so much he envisions him killed with a cleaver. Having cradled the infant in his hands, now "All I am to him is some asshole bully." Tony refuses FBI agent Harris's request for any information about security at the docks, suspicious Arabs, and possible terrorism: "I think there's a word for that." His reflex against snitching would imperil his country – and his own family. Meadow uses the NYC tunnels. Tony's response to this confusion of duty is to blame his Polish housekeeper for leaving him to bring in the morning paper: "Too dangerous. Has been for years." That denies the greater danger. Tony can tell Melfi "I've been coming here for years. I know too much about the subconscious," but he has yet to act responsibly on that knowledge. In contrast to Phil's and Carmine's broader sense of life, Tony reverts to his old ways and vile means, having lost his post-surgery harmony. The "degenerate fuckin gambler" is also betting heavily on sports again. He reverts from – in Carmine's phrase for the two rear-mirror danglers in *Cleaver* – from "the sacred" to "the propane." Some reforms are just gas.

In contrast to Tony's knowledge of the sub-conscious, Christopher doesn't understand the life-source of his fiction. "Who knows where it fuckin came from?" So, too, Johnny Sack's "ironic" observation that his lung cancer struck only after he ended 38 years of smoking. He denies his responsibility. Christopher is sensitive enough to acknowledge at the preview Anthony Soprano's seminal support for the project. But he fails to let the director – the real filmmaker—speak. Chris assures his counsellor he is still on the wagon, though his colleagues have misinterpreted why he is avoiding his familiar, tempting haunts.

This episode is entirely black until the last scene, the christening of Chris' and Kelli's baby Caitlin, where finally Tony and

Christopher hug each other—however warily. When Ginny and Allegra hug Johnny at the implication he is dying, the prison guard insists: "No physical contact please…. Ladies, no contact." Paradoxically Ginny's last loving gesture is to offer her dying husband a cigarette – having criticised his smoking. Feldman overcame Ginny's anger by explaining that Johnny is trying "to die as he lived, in total control." Or with that delusion. In the New York struggle over Johnny's succession, Silvio is splattered with blood when a posh dinner with their goomahs ends with Gerry Torciano's murder, disrupting Chet Baker's *Summertime*.

When Geraldo Rivera interviews mob experts on Johnny's possible successors –Leotardo, the feared but disliked Gerry Torciano, the Old School frontrunner Doc Santoro, or Carmine Jr. – Melfi's therapist Dr. Elliot Kupferberg makes a cameo appearance as gangland maven: "This Santoro thing – I called it a year ago."

The other relationships seem crumbling too. Meadow archly dismisses any mention of Finn. At Blanca's snappishness, AJ doesn't know if they've had a fight. Notwithstanding his thin beard and for all his promising start in their relationship, he lacks the sensitivity or experience for this woman. "I asked if you wanted popcorn," he replies to Blanca's hunger after the premiere. When she translates his celebrity hunger to wanting to sleep with Paris Hilton, Blanca may have sensed his infidelity.

When Phil Leotardo honours his murdered brother Billy's 47th birthday and places his ashes over the bar he loved, he like Tony begins to lose his new sensibility. As he rues Tony B's murder of Billy and regrets his own 20-year jail sacrifice for his Family, he turns ominous: "No more of this."

The episode closes on the nihilism of the John Cooper Clarke rapsong, *Evidently Chickentown*, with its relentless drums and "Bloody." The litany from "Bloody babies" to "Bloody ladies, bloody guys, Bloody murder in their eyes," provides a sinister undercurrent to the Moltisanti communion, Phil's brief reform and overall Tony's hardscrabble security and putative honor.

VII, 3 Remember When

Written by Phil Abraham. Directed by Terence Winter.

When Larry Barese leads the Feds to unearth the remains of bookie Willie Overall, Tony's first whack (Labor Day, 1982), Tony and Paulie flee to Miami, where they find a new partner for stolen goods.

At the therapy center Corrado and young patient Carter Chong run a furtive poker game where Corrado sells forbidden pop and candy. After Barese pins Overall on Jackie Aprile Tony celebrates by taking Paulie on a fishing trip, where both men consider Paulie might join Big Pussy and the fishes. After Doc Santoro's "taste" extends to taking food from Phil Leotardo's plate Phil has Santoro killed and becomes "the main guinea over there."

This episode centers on the ambivalence of nostalgia. Paulie and Tony glow in the recall of good times, Paulie assures Tony of his father Johnny Boy's love and Beansie assures him of Paulie's. But the sweet is tinged with the bitter, whether of failure, change or betrayal. Though she doesn't realize Tony's danger, Carmela worries "this is what life is still like, at our age?" The various betrayals, real or imagined, add a sinister note to the title of the closing Gene Krupa drum number: *Sing, Sing, Sing (With a Swing)*.

The unearthed body is an emblem of reviving the past. Whacking the bookie at 22 "made [Tony's] balls," a week before Meadow was born. The assignment proved Johnny Boy's trust in his son and fixed Tony's bond with Paulie. As the body has changed, the storied Havenaire Motel has been supplanted by a Marriott. The posh new hotel can't give Tony and Paulie a bottle or a late steak.

In the prison hospital Uncle Junior revives his blackmarket dealing and a pathetic Executive poker game. The high stakes, $10 red buttons, prove his decline. The inmates laugh at his jokes but are not up to the game. An Alzheimer's case, in a "Grandpa Rocks" shirt, wins the pot unawares with two jacks. Corrado's new comforts –enchilada night and a Kit-Kat over the shopping channel—trump Uncle Pat's proposal to spring him via an outside dental appointment. Corrado's venture fails when his bribed orderly, Jameel, for whom Corrado signed photos to sell on eBay, is fired. After he assaults former Rutgers Professor Lynch (jailed if not untenured for stabbing his dean), Corrado's new meds leave him stupefied. But when he dumps them he forgets his punchlines and wets himself. Resuming his meds and contact with the professor, he separates from Carter, who feels betrayed and attacks him.

Like the Sopranos, Carter is troubled by childhood memories. When Corrado recalls his father hitting him for refusing a quarter tip, Carter recalls his father's complaint at his 96 score on a Grade III spelling test and explodes: "Fuck you. Fuck you." He insults his mother when she warns against Corrado's violent effect on him. Carter has no-

one to assure him of his lost father's love, as Paulie and Beansie assure Tony, so he assaults his current paternal figure, Corrado. At one point Corrado calls Carter "Anthony."

Corrado's appeal to Vice-President Cheney—himself "all too familiar with accidental gunplay" -- refers to the hunting accident when Cheney shot a friend in the face. After the form reply, Professor Lynch recommends Corrado write Cheney "at his outfit, Haliburton." Given the company's rich benefit from the Iraq engagement, their former executive might appear still in their employ.

For Paulie and Tony suspicion as well as love is mutual. Tony is irritated by Paulie's chattering and indiscretion (*e.g.*, calling the crippled Beansie a "stand-up guy"). As if to find an excuse to kill him, on the boat *Sea Vous Play* Tony tries to draw Paulie's admission he reported Ralphie's insult to Ginny (IV, 2). In this delicate approach Tony raises his pinkie to eat his rigatoni. After considering an axe and a fishing knife Tony settles on hurling a painful beer: "Think fast!" Paulie dreams he asks Big Pussy, "When my time comes, tell me, will I stand up?" Feeling vulnerable, Paulie steps up his weightlifting and sends Carmela a $2,000 espresso machine.

Betrayals continue. After professing loyalty Phil Leotardo has Doc Santoro killed. Though Larry Barese leavens his betrayal by fingering Jackie Aprile instead of Tony, he still contrasts to the steadfast Hesh lending Tony $200,000 to cover his gambling debts. So, too, Beansie's loyalty to Tony – after Richie Aprile crippled him (II, 3). Beansie sets up Tony's new partnership, provides girls, and warms the men with his old photos of young Paulie, Johnny Boy and Uncle Junior. Knowing how his therapy opened him, Tony is discomfited by the others' reminiscence: "'Remember When' is the lowest form of conversation." He considers Paulie a dangerous babbler whose lack of a steady income leaves him "vulnerable to the Feds." In defence Beansie cites Paulie's solitude: "People live alone they get like that. It's sad." An edit confirms this, from Carmela packing Tony's boxer shorts to Paulie packing three pairs of white loafers.

In a variation on the nostalgia theme, the episode evokes classic movies. Doc Santoro is shot in the right eye, like "the Moe Green special" (I, 4) in *Godfather I*. Corrado's pretenses to bring fun to his fellow inmates and to avert numbing drugs recall the less selfish Jack Nicholson character in *One Flew Over the Cuckoo's Nest*, Milos Forman's 1975 film of the Ken Kesey novel. When the episode closes on Corrado, bitter and confused, the kitten in his lap contrasts him to Don Vito Corleone's first scene. Corrado has Vito Corleone's power,

dignity and authority only in his own deluded mind. He assumes he's generous when he pays Carter—with a handful of red buttons. When Tony flees when "My tomatoes are just coming in," he recalls Don Vito's more comfortable death, while playing with grandson Anthony in his tomato patch.

VII, 4 Chasing It

Written by Matthew Weiner. Directed by Tim Van Patten.

Vito Spatafore Jr. goes Goth, vandalizes a cemetery and is expelled for defecating in the gym shower. His mother asks Tony for $100k to start afresh in Maine, but Tony holds her cousin Leotardo responsible, having whacked Vito. When Carmela finally sells her spec house – to her cousin Brian – she worries about the sub-grade lumber. Blanca accepts AJ's proposal, then ends the relationship. Tony's gambling alienates him from Hesh.

Tony has held Livia's disdain for "degenerate fuckin gamblers" ever since his father hacked off Satriale's finger for a debt. His compulsive sport and casino gambling shows his current disintegration. When he wins big he blows it all on another bet. Whether he is chasing money, the high from winning, the thrill of the risk or the masochist pleasure of losing, gone is his post-surgery peace. In contrast Howling Wolf sings "I enjoy things Kings and Queens can never have."

Tony's losses impede his duty. Frustrated, he urges Carlos to suck cocks because Vito earned three times more. After Phil's and Tony's paternal chats fail to reform Vito Jr., Tony gambles away the $100k he'd planned to give Marie and instead sends the boy to an $18k Tough Love camp in Idaho. "There's no geographical solution to an emotional problem," he rationalizes. He fails to deliver on his gut-felt sympathy, "with Vito's passing and all that that entrailed." Still, he exceeds Silvio's prescription, to get Vito a dog. Compounding Tony's indignation, he watches Nancy Sinatra sing *Bossman* to Leotardo, who claims to have been at the telethon where her father Frank – a better peacemaker than Phil—reunited Dean Martin and Jerry Lewis.

Tony's $200k loan ruins his lifelong friendship with Hesh. He is also slow with Hesh's share of the MRI scam (I, 1). Hesh's insistence on only a modest "vig" (interest) only irritates Tony, who

makes begrudging weekly $3k payments. Where early Tony confides in Hesh, Hesh can now confide only in his family. In their new hostility both men lapse into ethnic stereotypy. Tony calls Hesh Shylock, dons a Comic Jew accent, throws a payment at him, then taunts him by rubbing coins together. Hesh moves from comfortable self-deprecation – his joke about the Jewish plane hijacker who claimed the miles – to fearing Tony will kill him to avoid repayment. Though Tony rejects Bobby's advice to stiff him, spotting the two Arab hoods may suggest having them whack his Jewish friend. When Hesh's mistress Renata dies of a stroke Tony settles the debt with a full shopping bag but leaves after a perfunctory condolence: "I'm sorry for your loss." Their friendship is finished.

Tony's gambling also alienates Carmela. He urges her to bet her Spec House profit ($600k) on an NFL game on which he has inside dope.. Though he wins his modest bet he is irate that she refused to turn her "bullshit into a fuckin million dollars." Carmela also rejects his claim on half her house profits. Though she has little to celebrate in unloading her suspect house on her own cousin, Tony viciously deflates her delusion of independence: "You're a shitty business woman who built a piece of shit house that's gonna cave in and kill that unborn baby any day." He grabs her roughly and she throws a vase at him. In his apology he affirms that surviving the gunshot was the big gamble. But his compulsive chase undermines that good luck. Renata's sudden death counters the confidence Tony takes from his own survival.

As he grows insular Tony's anti-Semitism perturbs Melfi: "There are a lot of Jews in your business, right?... Ya gotta hand it to them, when it comes to money?" Though he claims "This is an oasis in my week" she confronts his absences: "Decide if you want to keep coming. But know there are protocols that have to be followed or I won't be able to continue." His financial insecurity makes Tony uncomfortable even among his cronies. Paulie, Silvio, Chris and even Bobby are all killers who could seek to supplant him. In outrageous self-unawareness, he tells Hesh that Chris's film *Cleaver* – which Tony helped finance—is "very unflattering to Italian-Americans." He tells Carmela that her "cousin Brian fucked over a lot of people, trust me" – thanks to Tony.

The two troubled sons contrast. Vito Jr. points out that Tony has usually called him Carlo. As that is the name of the gunsel Tony gave Vito's business the mistake confirms Tony's sense of continuity between father and son. On the heavily made-up Vito Jr. Phil and Tony urge their homophobic manliness. Phil tells the kid he looks "like a Puerto Rican whore. You make me sick": "Your family's had enough

shame. It's up to you to set things right. You understand me? Be the kind of man [your mother] needs, strong. Masculine." Tony repeats the theme: "I'm sure you miss [your dad]. A lot. Whatever he was.... You're the man of the house now. Start fuckin acting like it." Their brutishness aligns with the homosexual insults Vito suffers in the gym shower. His excretory response unwittingly bears out Leotardo's obsessive quip: "I guess the turd doesn't fall far from the faggot's ass."

As Vito affronts decorum, AJ breaks free from his Family conventions. After romantically sending Blanca his engagement ring as a dessert, he makes an honest, plausible plan. Promoted after three months to night manager at the pizzeria, he will soon advance to day manager, thence to having a chain of clubs and restaurants. Though Blanca doesn't quite feel love for AJ, her detachment from Carmela's mansion sale celebration suggests she may fear moving into his world. (In VII, 5 AJ suspects his family's wealth may have put her off.) As AJ has outgrown Vito Jr's delinquency, he tries to play his business and love lives straight. That's a less heady gamble than his father's, but losing still hurts.

VII, 5 Walk Like a Man

Written and directed by Terence Winter.

Blanca gone, AJ's crying fits and suicidal mien worry his family and cancel Tony's decision to stop seeing Dr. Melfi. Chris's abstinence rankles Tony and Paulie, leading to a violent feud when Paulie robs Chris's father-in-law Al of the power tools he is fencing. To appease Paulie Chris resumes drinking, but his sappiness about his baby daughter provokes Paulie's insults. When JT rejects Chris's dangerous confessions Chris kills him. In return for a letter acknowledging his "cooperation and service," Tony gives Agent Harris the name and cell phone number of an Arab hood who disappeared into the fundamentalist community.

<center>***</center>

As the exploration of manliness comes to a head, Tony's session with Melfi opens on a close-up of the female statue that discomfited him in the series' first shot (I, 1). The visual echo reminds us that Tony has not progressed essentially since our first meeting. For all the promise of his post-surgery reform, he has relapsed into his initial callousness and self-destruction. Tony dropped Melfi ostensibly because "This therapy is a jerk-off.... I hate this fuckin shit." Chris equated his unmanly abstinence with Tony's therapy. Chris's new

strength Tony and Paulie deem weakness. "Show some balls" and have a drink, Tony insists. By avoiding the Bing booze and Satriale beer Chris can in brief honesty claim "I got balls." But Tony sneers, "I know a crutch when I see it."

In Tony's perverse sense of human nature, the half-billion-dollar industry aimed at heartbroken lovers is not psychology or medicine but blues music. He encourages AJ—"You're handsome and smart and a hard worker, and … let's be honest, white. That's a huge plus these days" –then suggests a blowjob, a remedy AJ finds as inadequate as Carmela's French toast.

In Tony's self-fulfilling world view, "Everything turns to shit." As all the characters deny responsibility, Paulie accepts Chris's apology with "Forget about it. Shit happens. What are you gonna do? There's no point in ruminating." At that Chris orders a drink. When Tony appears to take responsibility he only melodramatizes his own victimhood (Livia's "Poor you" syndrome). Having rejected Chris's claim that his alcoholism is an inherited disease, Tony claims to be responsible for AJ's depression: "My rotten fuckin putrid genes have infected his soul. That's my gift to my son." Tony's real damage is not genetic but moral.

Under Tony's influence both his "sons" dissolve into what's here considered unmanliness. Their crying echoes in Paulie's "It's my fault your father-in-law is a cry baby?" (*i.e.,* complains at being robbed). From crying they recover via ostensibly manly dissipation and violence. Tony blames Paulie's disrespect on Chris's absence. Chris throws Paulie's nephew Jason out a second-storey window. Paulie tears up Chris's $40k landscaping. Tony enjoys both Chris's relapse into drunkenness and Paulie's cruel jokes (*e.g.,* Chris's baby Caitlin will grow up to work the Bing).

As Chris manfully acknowledges that his legendary father "wasn't much more than a fuckin junkie" and his mother remains an alcoholic, he strives to stay clean. But as his weekend barbecue (*cp.* Tony's in I, 1) welcomes his family, Paulie's revenge brings the Family destruction to Chris's new home. Worse, his alienation from his beloved Tony drives him to blab about Adriana's death to Stan from AA, then to tell JT even more, even the allure of the Witness Protection program. As Paulie does Chris's, Chris interrupts JT's recovery, as he works to a deadline on a *Law and Order* script. As Tony criticizes both his indulgence and his abstinence, Chris kills JT for not listening to his mortally dangerous Mafia secrets. These irresolvable conflicts derive

from the Soprano "manliness," which forbids natural emotions and honesty.

The same moral confusion plays around AJ's ostensible recovery. At the sight of a loving couple – to Dido's *White Flag*—he surrenders to sentimentality and quits his pizzeria job crying. Carmela's truncated adage – "It's better to have loved and lost, AJ." – is as ineffectual as Melfi's offer to recommend a therapist ("After that incompetent you sent Meadow to?"). AJ's anti-depressants are the non-moral panacea Dr. Krakower rejected (III, 7).

AJ is restored by what Tony – to Carmela's horror – prescribes: the underaged, emotionally upset boy gets drunk and lap-danced at a frat party at the Bing. AJ snaps out of his "unmanly" emotions by resuming the sex, booze and drugs that are the Sopranos' proper (*i.e.,* perverse) measure of a man. He also indulges his ambivalent fascination with violence, when he helps pin the welching Victor while his mates pour sulphuric acid on his feet. That chemisty is like Tony's therapy, an abuse of education.

In another spectrum of manly values, AJ's life is reflected in his TV fare. His childhood reflects in the stylized violence of a Tom and Jerry cartoon. The hero of *Annapolis* (Justin Lin, 206) reverses AJ's experience, moving from a construction job to the military school AJ averted. His traumatic school football experience is recalled in the Harlem grid documentary *Hellfighters* (Jon Frankel, 2007), which Tony mistakes as the John Wayne melodrama of that title (Andrew McLaglen, 1968), his Old School.

When the Sopranos finally enjoy a normal late snack around the kitchen table, the presiding spirit is Tony's corruption and Carmela's pragmatism. For all the family harmony, only Carmela's phone call prevented Tony's tryst with the Bing dancer who blew him when Carmela was in Paris. The last scene images the family's fragility. The broken Chris tries to replant one broken sapling to make up for the ruined landscape.

As Chris considers singing to the Feds and Tony – at a Satriale sitdown—gives FBI agents Harris and Goddard some helpful information, the moral landscape continues to blur. Tony envies Patsy Parisi less for his son's computer wizardry than for his success as a campus bookie: "Majorin' in cash, minorin' in ass." Cheekily, the lads are awed by an acrobatic stripper to Muse's *Supermassive Black Hole*.

Among Al's customers for Chris's stolen power tools are off-duty police. Apparently the honest (*i.e.,* not on the take) cops moonlight

in construction, for which they eagerly buy stolen tools. Chris has a state trooper installing his dropped ceiling – a metaphor for lowered ambitions – in his mansion basement. In another image of decline, the opening shot pans down from the classy pseudo-Renaissance religious painting behind the bed to Tony grunting awake below. Chris stumbles home to Los Lobos's *The Valley*. The macrocosm is suggested by Carmela's bedside reading, *Rebel in Chief*, Fred Barnes' defense of President G.W. Bush's policy as "the future of Conservatism." Again, Bush parallels Tony in his command of amoral and destructive allegiance.

The moral issues around Tony's manliness have occupied the drama since its opening shot. As Tony was consumed by his gambling his perverse ethic pulls his charges from possible salvation back to his doom. This the next episode finalizes for Chris.

VII, 6 Kennedy and Heidi

Written by Matthew Weiner and David Chase. Directed by Alan Taylor.

Tony resists Phil Leotardo's demand for a 25% cut of the fees for illegally dumping asbestos at the Barone garbage site. After the stoned Christopher rolls the SUV to avert a head-on collision Tony smothers him to death. Tony accepts the consolations but feels relief at the loss. On a Las Vegas retreat Tony has sex and peyote with Christopher's college stripper friend Sonya, then gambles, breaking his losing streak.

Two elements give this episode a compelling immediacy. The minor is a series of very current pop culture references, especially the backdrop TV appearance of Katherine Hepburn on *The Dick Cavett Show*. Turner Classic Movies reran the October 2, 1973, interview three days before this episode (Thursday, May 11, 2007). The clip broke the distancing of a filmed TV show, as the audience could share the characters' TV schedule. In the major, Christopher's shocking despatch occurs so early that the climax becomes Tony's cold response. As both elements play against the show's being prepackaged, they both disorient and engage the viewer, like Brecht's break of the fourth wall in theatre.

The episode opens bathetic on dumped garbage and closes on a paradoxical high. As Tony and Sonya watch a spectacular desert sunrise Tony exults, "I get it!" The peyote feeds his sense that he is at

a peak, having rid himself of "the biggest blunder of my career" (Chris), accrued a beautiful young lover and scored at roulette. Despite the Las Vegas luxury, including free transport by private plane, the Pompei and comic devil slot machine emblems make the casino infernal. In his peyote high Tony hits his nadir. He is as toxic as the asbestos garbage he has just had dumped into the river.

Itching to confess, Tony dreams that he tells Melfi he killed Christopher, Big Pussy and Tony B. In the event he only admits he does not grieve his "nephew's" loss. He resents Chris's neglectful mother "reaping all the sympathy and tears." "Guess what pity produces in the recipient? They shit on your pity." He suggests Carmela also feels relief at Christopher's death. His admitted hypocrisy—pretending to grieve Christopher—pales beside his murder of the young man he loved and whom he promised his own mentor to protect. At the wake Tony releases his cynicism: Chris's hysterical mother is "Fuckin James Brown now" and the dark-glassed widow Kelli "Jackie Kennedy." Hesh's absence is a reminder of Tony's increasing isolation.

Seeing Kelli breastfeed Caitlin sends Tony to Vegas. His intended solitude weighs so he calls Sonya, initially to report Chris's death. Having failed to develop Chris as his successor, he follows Chris into Sonya and peyote. Tony bristles at Sonya's post-coital mention of Chris, as Chris was with Julianna initially squeamish about going where Tony had been, if only in his thoughts. At his casino triumph the stoned Tony rolls on the floor laughing helplessly: "He's dead." His climactic "I get it" rather connotes "I've been hooked."

In Chris's "Regarding Phil, I gotta ask—Whatever happened to 'Stop and smell the roses'?" the lost value points to both Chris's and Tony's relapse into their respective corruption, Chris's drugs and Tony's power. To Chris's prophetic "Life's too short" Tony replies, "It's too short to live it as a fuckin lacky." Despite Chris's last delusion – "I'll never pass a drug test. I'll lose my license…. Call me a taxi." – he helplessly watches his beloved Tony suffocate him.

While AJ sinks into Tony's world, the garbage man warns his son away from eating and breathing where the asbestos is being dumped. As AJ joins the frat boys' decadence he audits a few courses. He's troubled into thought by a class on the roots of the Palestine-Israel conflict and a Wordsworth lecture against materialism. As the professor asks, "'The world is too much with us'…. Why such strong words against the material world?" The Wordsworth quote is followed by "Getting and spending, we lay waste our powers," which undercuts

Tony's "I get it" with the harsh reality of his waste management, from Chris to asbestos.

Tony's world is too much with AJ. He takes the two Jasons' advice not to be affected by his cousin's death. He laughs that Victor had his toes amputated after the acid penalty. Now AJ joins his friends' racist assault of a Somalian student. The wrecked bike shows AJ's regression from when he swapped his bike for peace outside Blanca's flat (VI, 12). Ambivalent about this violence, AJ expresses naive despair to his therapist: "Everything's so fucked up. I mean why can't we all just get along?" He has not yet settled into Tony's calculated stoicism: "What're you gonna do?"

The other characters prove as weak in their will. Sentimental, Carmela regrets ever suspecting Chris involved in Adiana's death. The amoral pragmatist pretends to a higher ground: "Why are we so quick to blame? What is the attraction in that?" Noting Julianna's beauty, Carmela is unaware of Tony's attempt at an affair. At Chris's wake his ex-mistress ambiguously admits "I'm a recovering addict. I owe him a lot." As Chris caused her relapse Tony is responsible for Chris's, Carmela's, AJ's and his own.

Paulie regrets having baited Chris – "Maybe I didn't do right by him either" – and expresses a Wordsworthian remorse for having fought him "over cocksuckin fuckin money." That warmth ends in fury when Christopher's wake outdraws his Aunt Nucci's: "What kind of testament is this to the spirit and generosity of the woman?... It's a fundamental lack of respect, and I'm never fuckin going to forget it neither." His righteousness is fueled by his own having cruelly abandoned Nucci when he learned she was not his mother.

Nucci has a fatal stroke returning from *Jersey Boys*, the musical about Frankie Valli and The Four Seasons. As Valli played gunsel Rusty Millio (Season Six) the allusion advance the drama's self-reference and currency. So, too, Chris veers into the oncoming lane just after his CD plays "The child is grown, The dream is gone." The song (pertinently titled) *Comfortably Numb* is on "The *Departed* soundtrack – a fuckin killer," an homage to Martin Scorsese's Oscar-winning return to his *GoodFellas* world.

And so to the episode's enigmatic title. Heidi and Kennedy appear only briefly, the girls in the car that Chris fatally averts. The girls prove Chris's innocent nemeses. Yet as Heidi has been driving after dark with her learner's license she is not entirely innocent. Worse, she flees the crime scene. The girls' witness might have prevented Chris's murder. To reverse the Tony/Bush fiat, those who do not act

against his criminality are for it. And another Kennedy may be hiding in this "Kennedy and Heidi," evoking Chapaquidick, where an impaired driving accident curtailed Ted's presidential run. Like Carmela's bedside reading in the previous episode, this title suggests the Sopranos' drama is not just about a guilt-edged family or Family but a nation, a culture, the America that has lost its ideals. The innocent are at best unwittingly complicitous in the criminal compromise of its values. Like the pop culture currency, Heidi and Kennedy implicate the innocent viewers in Tony's triumphal disintegration.

VII, 7 The Second Coming

Written by Tim Van Patten. Directed by Terence Winter.

As the toxic asbestos blows off the Meadowlands roadside dump, Tony saves AJ from a botched suicide. When Silvio cancels Phil's no-show jobs his Coco beats up foreman Rodriguez and steals his $320. Tony increases his tension with Phil when he breaks gunsel Coco's jaw for insulting Meadow. Carmela is thrilled by Tony's diamond watch gift from Vegas but throws it at him in a quarrel over AJ's depression. Meadow has been dating Patsy Parisi's son Patrick, whose ideas on justice prompt her switch from medicine to law.

<center>***</center>

Though buoyed by his "nephew" Christopher's loss, Tony sinks under the threats to his real children. After AJ's suicide attempt – in the family pool where Tony treasured his lost ducks (I, 1) and with the Family's traditional cement weight –Tony and Carmela selfishly blame each other for the boy's depression. Tony thinks Carmela has spoiled AJ. To Carmela, "You've been playing the depression card till it's worn to shreds. Now you've got our son doing it." In her delusion Carmela remembers "But he was always so happy. He was our happy little boy." That we haven't seen.

AJ recovers some moral awareness but retreats. Troubled by the Somalian student's beating, he echoes Tony: "I'm one individual. What could I do?... Why can't I catch a fuckin break?" He could have not pushed the Somalian into the assault. AJ transfers his responsibility, to Carmela for the "dorky raincoat" for which he was beaten up in Grade II, to Livia's nihilist instruction ("It's all a big nothing"). His childhood drug use was "self-medication." Now he can't move out because "I'm ill, Meadow. I'm on medication…. I need Mom's cooking" – which he spurns because the meat is sprayed with virus. But

Meadow's sensible advice – "You need to learn to shut stuff out" – approaches Carmela's denial.

AJ's world concern may just gloss his self-pity. He tells Dr. Vogel he's perturbed about the gap between Bagdad burn victims and the Minnesota obese, between his parents' wealth and Blanca's poverty, about the hopeless cycle of righteous violence in the Middle East and President Bush's plan to bomb Iran. But he clearly goes to far when he rejects the Borat film: "It wasn't fair to the people involved." With these Leftist reflexes, he seems genuinely engaged by Yeats's poem, *The Second Coming*. Yet he secretly drops the English course rather than write the exam.

In fact, that poem's apocalyptic vision applies to the entire seven-season drama. The center hasn't held, anarchy is loosed throughout Jersey and the world, the best lack conviction and the worst have a passionate intensity, and a rough beast slouches towards Bethlehem to be born. After the latter line Agent Harris – still suffering from his Pakistan microbe—has Tony identify his two suspicious Arab colleagues. As Meghan O'Rourke suggested in *Slate* (May 31, 2007), the focus on that familiar poem – which Yeats wrote after the Russian Revolution and expressed his vision of a radical historical shift every 2000 years – raises the possibility of a cataclysmic conclusion to the drama. Indeed, as Tony's initial anxiety and therapy were prompted by his lost ducks (I, 1), the Yeatsian underpinning may also include the poet's *The Wild Swans at Coole*, where "those brilliant creatures" leave the poet heart-sore when he hears "The bell-beat of their wings above my head." For the Soprano men's self-pity, though, the "rough beast" of a savage, destructive new order is Tony.

Undercutting AJ's new wisdom, Chase cuts from his remark about Blanca – "She's not black. I mean—she's pretty tan" – to Silvio reading *How to Clean Practically Anything*. The *consiglieri* may aspire to Harvey Keitel's clean-up man in *Pulp Fiction*, as he prepares for Yeats's blood-dimmed tide and the rough beast's moulting. When AJ hits the pool after reading the poem, only his "ceremony of innocence," not any real innocence, is being drowned.

After his angry "What's wrong with you?" Tony lovingly cradles the sodden AJ: "Come on, baby. You're all right, baby." His words recall Ralphie's moan over his son (IV, 9). But among his men that soon fades into his self-concern: "Stupid fuck. Where did I lose this kid? What did I do wrong?" Tony tells Melfi the botched suicide proved AJ "a fuckin idiot," incompetent at even "the coward's way out." In the family therapy session Tony echoes Livia—"Poor you. It's

all your mother's fault."—but is undermined by finding Coco's bloody tooth in his cuff.

Tony pretends to humanity, as when he appeals to his brief "understanding" with hospitalized Phil: "I'm talking to you here on the human level." But here Tony is trying to wheedle a lower cut for the dangerous asbestos dump, nothing "human" about it. In response Phil recalls his forced compromises in his 20-year prison term, threatens to halt the profitable Hackensack mall project, and rejects Tony's peace offering – a semi trailer full of Makita power drills—for having crippled Coco.

Tony still can't be honest. His watch gift clearly covers for his affair with Sonya, where he "had to take care of Christopher's business interests." So, too, Paulie blames the gangsters' various problems with their children on "all these toxins they're exposed to, it fucks with their brains," as the gang contributes asbestos to that mix. Indeed, Melfi's Dr. Kupferberg reports that studies have found criminal personalities are rather validated than corrected by talk therapy: "They sharpen their skills as con men on their therapists." Criminals in therapy have higher early reconviction rates. That supports Dr Krakower's pivotal rejection of Melfi's nonjudgmental approach (III, 7).

The final cut omits Melfi's scripted conclusion: "What are you saying? My whole work with Tony Soprano, all these years, it's all been a waste of time?" But her last session with Tony reveals that doubt. To her cliché, AJ's suicide attempt "could've been a cry for help," Tony briskly replies "Aren't you listening? He *did* cry for help. He's lucky I came home and heard him." Melfi grasps—"That's very insightful"—at Tony's peyote *apercu*. Mothers are like buses—they drop us off and go on, so we should let them go instead of trying to get back in. In context, however, this insight does not free Tony from his mother but from responsibility for his children. Like its peyote source, it's selfish escapism.

Tony does not share Patsy Parisi's enthusiasm for their children's possible marriage. Perhaps Tony is still wary, having had Patsy's twin brother murdered (II,1), despite Patsy's faithful service since. And as Patsy earlier consoles Tony, Patrick "can be a moody prick sometimes." As his more openly corrupt son Jason holds AJ in his thrall, perhaps Meadow's marrying the ostensibly idealistic Patrick would not transcend her Family origins as Tony wishes.

The episode ends on a melancholy shot of Tony walking away with AJ in the Mountainside psych ward, an echo of AJ's admission shot, two prisoners of self-pity. Tony has had to leave his usual

consolation – a pizza – outside. As Carmine has warned about Tony's "alteration" with Coco, he clearly is "at the precipice of an enormous crossroad." Tony's altercations show he has not changed.

Confirming Tony's failure at therapy, the closing folk lullaby, *Ninna Ninna*, recalls Tony's fantasy of a nurturing Isabella (I, 12). A mother tells her son Antoneddu ("little Anthony") she would rather he die than follow in his outlaw father's footsteps. The untranslated Italian leaves this message in family code, as it expresses the care Tony never got from his parents and is failing to provide his son. We hear the song; the Familial Tony can't.

VII, 8 The Blue Comet

Written by Alan Taylor. Directed by David Chase and Matthew Weiner.

For spreading "misgivings" about Tony, Silvio kills Burt Gervasi. Leotardo orders Tony, Silvio and Bobby whacked. Tony's pre-emptive hit kills Phil's housekeeper/goomah and her father but not Phil. Leotardo has Bobby killed and Silvio seriously wounded. Melfi ends Tony's sessions. The Sopranos go into hiding.

As the Yeats poem warned, "The center does not hold." Expectations are dashed. In the opening shot the man retrieving his morning paper turns out to be not the usual Tony but the turncoat Gervasi. Despite this relief Tony is under increasing threat.

His past is catching up. When Silvio cuts his hand strangling Gervasi we and Tony recall his similar wound on "Fred Peters" (I, 5). Phil's Ukrainian goomah Yarina recalls Tony's dumped Russian Irina. When Carmela takes the kids to hide in her new estate house, she finds an unexpected benefit from her real estate career.

Two false idealisms collide here. Tony assures Carmela that the gangsters "don't touch the families." As Leotardo justifies killing Tony, the Soprano family is a mediocrity, with no respect for the traditions – like the blood oath and ceremonial gun and sword at a making. He sneers at Tony's trivial jail time. Phil is embarrassed that he took Tony's "fat fucking hand" in the hospital.

Planning the hit on Phil, Silvio and Tony playfully spar to *Cavalliera Rusticana.* Their slow motion points the music to Scorsese's *Raging Bull* and away from Coppolla's fuller use of the opera in *Godfather III.* Again, the Sopranos fancy themselves Corleones but are

living the petty, betraying lives from Scorsese's landscape. In a parody of the Christian right, Agent Harris greets Tony at Satriale's: "End times, huh? Ready for the rapture?" He informs Tony about Phil Leotardo's threat but not about the Moslems.

When Tony and Carmela dine at Vesuvio's, Charmaine and Artie are unusually friendly, perhaps cheered by the Sopranos' predicament. Charmaine celebrates Meadow's romance with Patrick Parisi and they accept the cheery report on AJ. Tony and Carmela profess relief that Meadow has dropped pre-Med for "Constitutional Law" (even here Carmela denies the "Criminal"). Carmela's rationalization – "But does compassion come naturally to her? Patience? I'm not sure." – is less attuned to her daughter than Tony is: "What are you talkin' about?" Meadow's compassion towards Moslems and Blacks trouble him about her choice of law.

Paulie may prove Tony's main threat. When Phil declares "It's over. We decapitate and we do business with whatever's left," he orders the killing of Tony, Silvio and Bobby. Perhaps he omits Paulie because he plans to do – or to continue to do – business with him. In Season IV Paulie tried to switch allegiance to Johnny Sack and Carmine. He may stay with Tony in the hideout not entirely out of devotion.

On Tony's contract on Phil a tortuous chain of command obscures responsibility. Tony assigns the arrangement to Bobby. Contacting the killers is passed from Silvio to Paulie to Patsy Parisi to Corky Caporale. As Silvio finally reports, "Paulie said he wants it known. It's on him. He takes full responsibility. But that he didn't do nuthin."

That avoidance of responsibility also appears at the dinner party where Melfi is betrayed. She suspects Elliot Kupferberg has another guest confirm his report on the sociopaths' exploitation of talk therapy. Then he unprofessionally identifies her gangster client. The possibly prophetic "Leadbelly" he explains as "a female opera singer and a gangster." "We're all professionals here," he weakly defends himself. His unprofessionalism is matched only by Melfi's petulance with Tony.

Melfi's final animosity reminds Tony of Carmela. With a betrayed woman's hurt dignity Melfi ends their relationship. She does not clearly state why, instead citing his selfish tearing a page out of her waiting room magazine. She anticipates Tony's answers—like his preferred strategy of a kick up AJ's ass – then amplifies: "Are you a shining example for the huge collection of wingtips and loafers that

must be lodged up your lower bowel?" After blaming her "female menopausal situations" he echoes Kupfberberg: "As a doctor I think what you're doing is immoral." Melfi's closing her door against him reverse-echoes Michael Corleone's closing the door against his Kay in *The Godfather I* and *II*.

Tony's behavior in the session could only confirm Melfi's doubts. He flatters her emptily. He asks what she "clears" in a year because he's concerned Meadow will earn less in law than in medicine. He turns Meadow's maturing into a problem, even as she realizes his hope she will escape the criminal life. Joining a large firm, that he expects will practice white collar crime, would be "Nice, but not Sopranos."

Tony again feels betrayed when Janice, claiming Bobby's support, wants him to keep Uncle Junior in the expensive private sanitariam. Bobby shows his financial strictures when he pauses before buying the $8k Blue Comet. When he's gunned down he falls on the model train display and dies under the miniature Newark station sign. This image parodies an empire crumbling.

Meanwhile Petey B and Ray-Ray leave Silvio in a possibly terminal coma, and in their escape kill a motorcyclist. Patsy escapes. The episode emphasizes the damage the gangsters do innocents, from Burt Gervasi's wife returning from Mass to the father and children traumatized in the hobby store attack– and ultimately to Bobby's children, left to Janice's care.

Tony takes AJ out of the "$2,200 a fuckin day" clinic, where "we don't do traditional therapy, *per se*." Tony appreciated AJ's treatment, even though the Plumbers' Union health plan paid only 10% on mental. There AJ connects with a friend's ex, Rhiannon, a young model struggling with food issues and depression. As Tony rushes his family into hiding he roughs AJ out of his self-pity: "Uncle Bobby's dead. This is really depressing to me." Validating Tony's violence, AJ appears dressed and outside talking to Rhiannon.

The episode closes on Tony, against a contemplative instrumental – The Tindersticks' *Running Wild*—lying on his upstairs hideout bed, his finger on the trigger of Bobby's birthday gift AR-10 rifle. The gun recalls Tony's corruption of Bobby (ordering his first kill), Bobby's generosity and in the model train lover's death the continuing tighten on Tony and his petty power.

VII, 9 Made in America

Written and directed by David Chase.

At a peace-making sit-down Butch frees Tony to act against Phil and invites Tony's "number" to compensate for Janice's loss. On Agent Harris's lead Tony has Phil killed. Carlo flips to the Feds after son Jason is busted for selling Ecstasy. Paulie declines captaincy until Tony says he'll give it to Patsy. The Sopranos and Parisis plan Meadow's and Patrick's wedding. AJ decides to join the army to fight in Afghanistan but settles for the "entry position" of "development executive" (aka "gofer") in the Daniel Baldwin film project Tony arranges with Carmine. When the Sopranos meet for dinner the diner's ominous atmosphere ends on a dark blank screen.

With a climactic anti-climax the drama's last episode ended weeks of public speculation about the characters' fate. Chase's enigmatic conclusion settled everything and nothing. By rejecting closure and the viewer's satisfaction it confirmed his independence from narrative convention. To the end more like life than like TV, the Soprano characters may just be left to go on. Chase's ending was unpredictable yet inevitable.

Consistent with the drama's paradoxical nature, the ending is both happy and tragic. Tony's survival would be tragic because it would extend his moral failure. His death would be the happy ending, justice. The ambiguity of the final, black screen admits both equally. Whether Tony lives or dies is minor. For his human failure leaves him in a death-in-life. At Bobby's wake Paulie encapsulates this ambiguity: "In the midst of death, we are in life. Huh? Or is it the other way around?... Either way, you're halfway up the ass."

As the title confirms, the general mix of ideals and corruption, aspiration and denial, delusions and defeat, characterize contemporary America. More innocent satires of America, the current *Little Miss Sunshine* and the classic *Twilight Zone,* play on the comatose Silvio's TV and in the safe house, respectively. At Bobby's funeral AJ erupts against the silly TV and Oscar chat: "You're living in a dream." AJ takes seriously Jason Parisi's joke they should join up to "go kill some fuckin terrorists": "It's more noble than watching jerk-off fantasies on TV if I were kicking their asses." Pronouncing the poet Yeats like "meats," he bemoans America's corruption and echoes Tony's immigrant idealism: "It's like – America, this is where people came. To make it. It's a beautiful idea. And what do they get? Blame? And come-ons for what they don't need and can't afford."

High-school junior Rhiannon snaps AJ out of his funk. Bob Dylan's *It's Alright Ma (I'm only Bleeding)* leads to their first sex, until AJ's SUV catches fire from the dry leaves under his catalytic converter. He tells his new therapist the SUV's explosion felt like a cleansing. When this spectacle of destruction excited him he relishes the practical switch to public transport. "We have to break our dependence on foreign oil," he recites. He buys Arabic lesson CDs.

But AJ's idealism remains rooted in materialism. Joining the army could get him helicopter pilot training that could get him a job with Donald Trump. His ambition stays in the TV fantasy (*i.e.,* the Donald's ostensible "reality" contest show) that he spurned. Or his openness to the Afghanistanis could make him a liaison officer and then a CIA operative. He readily abandons the military sacrifice for a film job— with a sporty new BMW. This career puts AJ on the course that doomed Tony's adoptive "son," Christopher. Cured of conscience, AJ laughs with Rhiannon over chips and the TV where Karl Rove raps and the President dances.

In his film project a private eye is sucked into the internet to solve the murders of some virtual prostitutes. Again Chase plays on the relationship between life and fiction, actor and role. The plot may also reflect on his audience's demands for his fiction's conventionally satisfying conclusion and his open-ended alternative. A *Twilight Zone* character remarks that in TV "The writer is [reduced to] a major commodity."

Like AJ, Meadow's legal career is stuck in her past. As she explains her switch from medicine, seeing her father's arrests proved "The state can crush the individual." For her, the gangster's arrests were anti-Italian prejudice to which his guilt was irrelevant. That's Carmela's denial. But rather than defend oppressed minorities, like her volunteer work with blacks and Moslems, Meadow will graduate into her fiance's big law office –starting at $170k – that defends a county commissioner against corruption charges involving bid rigging, bagmen and whores. While this idealistic rebel reverts to Tony's little girl, her bulemic playmate Hunter (still played by David Chase's daughter) has straightened out and is in second-year Medicine.

Meadow's probable cases are foreshadowed in Tony's scene with lawyer Mink. With Carlo testifying Tony will likely be charged with homicide. But "Trials are there to be won." The men take out their frustration on the stubborn catsup bottle which, as it fails to pour out the red stuff, emblematizes the episode's relative bloodlessness. To

general disappointment, the only death we see is Phil's shooting, with his head crushed by his SUV off-camera.

After 86 hours Tony has reverted from his brief spiritual phase to the angry selfish brute he was at the outset. His potential gleams through his soft spot for the stray cat – an antithetic reminder of his ducks in I,1 – and his pause to enjoy the air as he rakes round his pool, recalling his post-surgery awareness. But he returns to his old workways and encourages his children to his corruption. Perhaps Tony's last emblem is the onion ring– overdone, unhealthy, flavourful but indigestible, and empty at the core.

Janice remains Janice. She rudely charges a nurse with impoliteness. When she jokes about staying slim "to snag another husband," she appreciates Tony's understanding. She wants to try to mother Bobby's children and claims a bond with Sofia, but she needs her help to raise Nica. Bobby Jr she will let move to his aunt. Her claim to improvement does not hold up: "I had therapy. I'm a good mother. I put Ma and all her warped shit behind me…. Not that I get any thanks for it." Within a breath her Livia element returns. So, too, her attempt to enveigle Uncle Junior of his money.

Uncle Junior's failed memory reveals the lasting hold of his Mafia upbringing. He doesn't recognize Janice or Tony. Janice's report of Bobby's death he mistakes for the bad, anti-crime Kennedy's: "Ambassador Hotel." But Tony's "This thing of ours" Junior remembers: "I was involved in that?" He's pleased to hear of his and Johnny Boy's importance there.

AJ's new therapist confirms the sense of continuing pattern. Elegant, earnest, the Wasp version of Melfi crosses her long, beautiful legs. She discreetly deflects Tony's and Carmela's request she dissuade AJ from the army. Carmela sees through Tony's claim his unloving mother "was a borderline personality" but stays in denial: "Maybe the army'd be great for [AJ], if there wasn't a war going on."

In the only major character change FBI Agent Harris has sunk to Tony. The FBI surveillance protects the Sopranos at Bobby's funeral. When Tony reports the suspicious Arabs' bank, Harris says Tony is "over-reaching" to expect him to help find Leotardo. But he later tells Tony Phil has been traced to Oyster Bay. From that pearl, when a colleague reports Phil's death Harris reacts as if he were on Tony's team: "Damn, we're gonna win this thing." His colleague is properly disturbed, for Tony is likelier to testify under Phil's living threat. As Big Pussy acted like an FBI agent, Harris turns Soprano. Thus the upstanding lawman is curt and impatient with his wife on the

cellphone, then furtively phones Tony from his matinee tryst with a colleague. As he betrays his wife with the girl, he betrays his colleague with his call to Tony. The *goomah* equates the legal hunter and his gangster prey.

The scene where Tony leaves Paulie sunning himself outside Satriale's with a reflector replays a harmonious scene in II, 11, when Agent Harris introduces his new partner to Tony. That scene established a new harmony in the gang that survived Carmine Jr's car crash. The echo feels ominous here.

Paulie stays silly. Having chafed at Tony's disregard, he rejects his promotion because the unit's other captains have died prematurely. He confuses time and space: "You could take 2007 and give it back to the Indians." Paulie's antagonism towards the stray cat that stares at Christopher's photo coheres with his superstition-cum- religion. When he confides that he saw the Virgin Mary at the Bada Bing (after hours), Tony shows limited support: "Why didn't you say something? Fuck strippers, we coulda had a shrine. Sold holy water in gallon jugs, we coulda made millions." Even Paulie's acceptance of his promotion – "I live but to serve you, my liege" – shows a resentment that could betray Tony.

And betrayed Tony may still have been. For there is a strong case for the conclusion Tony is whacked. The closing restaurant scene is played as ominous. As we get Tony's perspective on the other characters we get a sense of the crime boss's unflagging wariness. The very last shot, then, the no-life blackout, may be his last view. Indeed, as the Sopranos pop the whole onion ring in their mouth, sans bite or chew, the hint of communion, in profane deep fry, suggests this might be their last supper.

While Bobby's wake was at Vesuvio's, Holsten's suggests nostalgia and casual comfort rather than class. The diner shows Tony's decline from Artie's fine dining. The diner is not as drastic a comedown as Carmela's refuge, an old house reeking from the previous owners' urine. But as the bus tour guide passing Holsten's notes, from a once thriving neighborhood Little Italy is "now reduced to one row of shops and cafes." As well, the diner is filled with the "schnooks" to which Harry Hill, the turncoat hero of *GoodFellas*, was reduced, fleshing out Tony's dread.

Tony takes a booth from which he can watch the door –and not just for his family's separate arrivals. In a flourish of metaphors, from the tabletop juke he plays Journey's *Don't Stop Believin'*. "Journey" sings off the end of Chase's – and thereby Tony's? The lyrics point to the

ambiguous end: "Some will win, some will lose, Some were born to sing the blues. Oh, the movie never ends. It goes on and on and on and on." As Tony flips through the juke, Chase shows the song's flip side, which implicitly leaves the ending to the viewer: *Any Way You Want It*. Tony also lingers but passes over Heart's *Where Will You Run To*? and *Magic Man*, and over Tony Bennett's *I've Gotta Be Me* and the synonymous *A Lonely Place*. These titles summarize Tony's condition.

Though AJ cites Tony's valediction from the end of I, 13 -- "Focus on the good times."—we pick up Tony's wariness. We read his suspicion into the truckdriver in a USA cap, the strong young man with a date, the black duo who enter last. Even the man with three boy scouts recalls the innocent customers at hobby shop where Bobby is killed (VII, 8). The man who walks past the Sopranos to the WC behind Tony may relive Michael Corleone's Family initiation, when he retrieved a gun from the toilet box (*Godfather I*).

His "Members Only" jacket recalls the opening episode in Chase's concluding epilogue, VI,1, which was titled Members Only, after the jacket Eugene Pontecorvo wore when he kills a man in a diner like the one here. The man here stands tall and lanky like Eugene, who killed himself when Tony wouldn't release him from the mob. The present scene may implicitly fulfil Eugene's wife's hope that someone would "put a bullet in [Tony's] head."

Meadow's difficulty in parking her car establishes a suspense we assume is life or death. The scene demonstrates Hitchcock'a conviction that dramatic power lies not in the explosion but in its expectation. Will she get there in time to die or late enough to be saved? The last words, as Tony sees someone—maybe Meadow, maybe not—enter, are Steve Perry interrupted at "Don't stop." But as art –whether a song or an epic drama – can't control life perhaps Tony's life stops with the show. We're deprived of Perry's last "believin'."

If the blank screen climax implies Tony has been killed it fulfills Bobby's warning in "Soprano Home Movies" : "You probably don't hear it when it happens, right?" In "Stage Five" Silvio describes Gerry Torciano's murder in similar terms. "He did not hear a thing" and didn't realize anything "until it was over." That's how Bobby was killed in VII, 8, Phil here, and by extension Tony now.

The end black reverses the episode's opening on Tony waking up in the safehouse. This is one of only three episodes without music over the end-credits. Where II, 8 ended on the beep of the wounded Christopher's life-support system, Tony here has no life-support. VI, 1 ends with Tony shot by Junior, unconscious, with no sound over the

end credits. So the ending of the first and last episodes of Chase's concluding epilogue (VI, 1; VII, 9) both take their cue from *Hamlet*: "The rest is silence."

Of course this remains surmise. We don't *know* Tony has been killed because we haven't seen it. Chase's conclusion spares/deprives us of the sensational thrill of his death, as he denied us Melfi's vengeance against her rapist (III, 4). In another way this reticence is a moral imperative. Knowing Tony is dead could give us false confidence that such unfathomable evil has been controlled. Like Iago, Tony is left in limbo because his evil and its reflection of contemporary America remain living dangers. We may assume he's dead but comfort lies elsewhere. As John Allemang put it, "For closure, look to *M*A*S*H* or *Friends*/ But Tony's torment never ends."[1] But it ain't over till the fat Soprano croaks.

[1] John Allemang, "Poetic Justice," *The Globe and Mail*, June 1, 2007.

Conclusion

Perhaps no other American TV show ever generated the controversy that David Chase's last scene did. It thwarted unprecedented expectations. The first airing of the last episode drew 11.9 million viewers or 7.2 million homes, the fourth-largest *Soprano* audience and the largest since the 2004 season launch. HBO's multiple screenings and video recording boosted the *Sopranos* audience immeasurably. Though the 30 million HBO home subscribers pales beside the 111 million homes that receive the mainstream networks without extra charge, the *Sopranos* close outdrew every other network show except NBC's *America's Got Talent*, with 13 million viewers.

The Sopranos reflected its time in its anatomy of a family driven by greed, selfishness, deceptions, whose very venality made them typical of more legitimate social pockets and institutions. The swelling references to America's political climate and international dangers further pointed the fiction.

Despite the climactic let-down, when we leave the Sopranos we feel the tragic peak, "calm of mind, all passion spent." Tony has the grandeur of a tragic hero but his grandeur is the reptilian force of his evil and determination. From Tony's violent outbreaks in I, 1 to his besting Leotardo in VII, 9, he is deeply disturbing in his shaming charm. So is the fiction, as Chase constantly violates our expectations to tease us into thought.

The Sopranos stands monumental, a drama of unprecedented length, concentration, density and resonance. It can be mined for themes, structures, ambiguities and reflections both quotidian and universal as rewardingly as Chaucer and Shakespeare. It demonstrates that American television can produce a true masterpiece, a fiction that is properly Adult, and that the TV audience will embrace complexity and challenge. There will, of course, be an audience that wants the drama softened, Bowdlerized, trimmed to decorum, as the Arts and Entertainment network found when they paid a million dollars per episode to air that travesty. But as Shakespeare survived the good Reverend Bowdler the true force of the original *Sopranos* will survive the tests not just of time but of timidity.

Additional Cast—Season Seven

Continuing
Blanca Selgado — Dania Ramirez
Hector Selgado — Kobi and Kadin George
Faustino "Doc" Santoro — Dan Conte
Domenica Baccalieri — Avery Elaine and Emily Ruth Pulcher
Kelli Moltisanti — Cara Buono
Butch DeConcini — Gregory Antonacci
Salvatore "Coco" Cogliano — Armen Garo
Walden Belfiore — Frank John Hughes
Anthony Maffei — John Cenatiempo
Burt Gervasi — Artie Pasquale
Peter "Bissell" LaRosa — Jeffrey M. Marchetti
Patrick Parisi — Daniel Sauli
Jason Parisi — Michael Drayer
Jason Gervasi — Joe Perrino
John Stefano — Joey Perillo
Edgar Ramirez — Felix Solis
Dominic — Dominic Chianese Jr.
Professor Kline — Lindsay Campbell
Agent Ron Goddard — Michael Kelly
J.T. Dolan — Tim Daly
Ahmed — Taleb Adlah
Muhammed — Dennie Keshawarz
Dante Greco — Anthony J. Ribustello
Dr Richard Vogel — Michael Countryman
Butch DeConcini — Gregory Antonacci
Rhiannon Flammer — Emily Wickersham

VII,1
Mercedes — Patrena Murray
Denis — Philippe Bergeron
Normand — Christian Laurin
Peter Acinapura — Zuzanna Szadowski
Woman — Stephanie Szostak
Paula Salerno — Antoinette LaVecchia
Jamie Salerno — Allyssa Magliaro
Lucy Salerno — Julia Thompson
Brad Salerno — Hunter Gallagher

French Canadians	Jean Brassard, Maxime DeToledo
Reporters	Paige Allen, Amy Kean, Paul Lombardi

VII, 2

Warren Feldman	Sydney Pollack
Sally Boy/ Himself	Daniel Baldwin
Eddie Dunne	Christopher McDonald
Michael the Cleaver	Jonathan LaPaglia
Anthony Infante	Lou Martin Jr.
Dr Ajit Gupte	Maulik Pancholy
Dr Uri Rosen	Seth Barrish
Morgan Yam	John Wu
Manny Safier	Matthew Weiner
Himself	Jerry Capeci
Priest	Martin Gobbee
US Marshals	Kevin McKelvy, Bruce Falk
Larry Barese's wife	Maria Iadonisi
Alexandra Lupertazzi	Ariana DiLorenzo
Nicole "	Allison Dunbar
Carmine " III	Sam Semenza
Film type	Derek Milman
Dominiqia	Jane Kim
Nicky	Lenny Ligotti
Frankie	George Pogatsia
JT Dolan's girlfriends	Susan Porro
Guard	Guy Fortt
Another patient	Ralph McCain
Donna Parisi	Anna Mancini
Billy Leotardo	Christopher Caldovino
Gerry's goomah	Jo Newman
Silvio's goomah	Julie Rogelstad
Photographer	Bruce Bennetts
Boys	Nicholas Mazzeo, Jacob Lobosco, Francesco Fusaro
Girls	Justine Caputo, Gia Bella Adamo

VII, 3

Carter Chong	Ken Leung

Peter "Beansie" Gaeta	Paul Herman
Jameel	Nashawn Kearse
Mrs Chong	Elizabeth Sung
Prof. Brian Lynch	Charles Morgan
Dr Mandl	Stephen Singer
Uncle Pat	Frank Albanese
Beppy Scerbo	Joe Pucillo
Warren	Stink Fisher
Val	Suzanne Hevner
Larry	Joseph Adams
Itzhak	Brian D. Coats
George	Stanley Harrison
Walter	George Reddle
Gary	Joe Rosario
Keith	Ptolemy Slocum
Ascot Man	Kevin Murphy
Ramon	Gaston Renaud
Esteban	Serafin Falcon
Lynn	Christina Cabot
Orderly	Chester West
Nurse	Donnetta Lavina Grays
Anika	Jen Araki
Clista	Ginger Kroll
Misha	Kate Rogal
Willie Overall	Herbert Rogers
Gia Gaeta	Donna Smythe
Hotel clerk	Patrick McNulty
Bellman	Lin-Manuel Miranda
Young Junior	Rocco Sisto
Johnny Boy	Joseph Siravo
Salesmen	James Coyle, Tod Engle, Ian Blackman

VII, 4

Nancy Sinatra	Herself
Southside Johnny	Himself
Maria Spatafore	Elizabeth Bracco
Brian Cammarata	Matthew Del Negro
Janine Cammarata	Heidi Dippold
Vito Spatafore Jr.	Brandon Hannan
Francesca Spatafore	Paulina Gerzon
Eli Kaplan	Geoffrey Cantor
Beth Kaplan	Tracey Silver

Renata	Lanette Ware
Anthony Maffei	John Cenatiempo
Albie Cianfione	John "Cha Cha" Ciarcia
Steve	Clarke Thorell
Back up singer	A.J. Lambert
Jesus Selgado	Carlos Morales
Ted Yacanelli	Mason Pettit
Jesse	Josh Kay
Max	Dillon Woolley
Dylan	Nicolas Marti Selgado
Boy	Colton Parsons
Roger	James Lorenzo
Fan	Drew Wininger
Croupier	Paul Mollo
Dealer	Jeanine Flynn
Basketball announcers	Kevin Garrity, Charlie Minn
Waiter	Joe Anania
Waitress	Poppy Cerqueria

VII, 5

Al Lombardo	Dennis Paladino
Rita Lombardo	Phyllis Kay
Joanne Moltisanti	Marianne Leone
Dr Richard Vogel	Michael Countryman
Terry Doria	Ron Castellano
Jason Molinaro	William DeMeo
Stan	Greg Connolly
Georgie	Frank Santorelli
Victor Mineo	Matt Sauerhoff
Donna Amato	Sistina Giordeno
Belinda	Belinda Bissonnette
Lori	Nathalie Walker
Mike	Nolan Carley
Greg	Michael Gibson
Moderator	Richard Litt
Felix	Mando Alvarado
Construction worker	Lawrence Bingham
Player	Ray A. Norberto
Lovers	John O'Hara, Brianne Moncrief
Tommy Giglione Jr	Anthony Piscolo
Alyssa Giglione	Madison Connolly

Woman	Jill Lord

VII,7
Teenager	Joey Scala
Surveyor	Ed Kershen
Driver	Edward Furs

VII, 8
Corky Caporale	Edoardo Ballerini
Eric Mangini	Himself
Julie Mangini	Herself
Ray-Ray D'Abaldo	Ricky Aiello
Petey B	Pete Bucossi
Italo	Carlo Giuliano
Roberto	Davide Borella
Yaryna	Matilda Downey
Yaryna's father	Aleks Shaklin
Evelyn	Susan Aston
Isabel	Merissa Morin
Derek	Henry Glovinsky
Arnold Bellows	Adam Heller
Stacey Bellows	Mimi Lieber
Yaolin	Connie Teng
Ken	Peter Benedek
Joyce	Shannon Koob
Ira Shortz	John Mainieri
Father	Jeff Talbott
Kid	Jan Colletti
Dancer	Lauren Potter

VII, 9
Donna Parisi	Donna Pescow
Dr. Doherty	Jenna Stern
Patrick Parisi	Daniel Sauli
Patty Leotardo	Geraldine Librandi
Hunter Scangarelo	Michele DeCesare
Uncle Pat	Frank Albanese
George Pagilieri	Peter Mele
Tara Zincone	Melanie Minichino
Priest	Don Striano
Gas station manager	Rajesh Bose
Mary	Anita Salvate
Paulie's friend	Mike Sullivan

FBI agents	Michael H. Ingram, Amy Russ
Nanny	Colleen Morris
Tour guide	Saidah Arrika Ekulona
Orderly	Tony White
Teens	Shortee Redd, Rydell Rollins, Dante Bacote, T.J. Allen
Lavoo	Alan Levine
In Diner: Man	Jimmy Spadola
Man in Members Only Jacket	Paolo Colandrea
Waitress	Carol Scudder
African-Americans	Du Kelly, Sharrieff Pugh
Truck driver	Patrick Joseph Connolly
Old woman	Patti Kerr
Old man	William Severs
Young woman	Adrianne Rae Rogers
Young man	Henry O'Neill

Appendix I

The Influence of *The Public Enemy* (1931) on *The Sopranos*

David Chase's influence by William Wellman's classic gangster film extends beyond specific details to the ambiguous overall intention of the work. Specific episodes pay explicit homage. In the most dramatic reference, when Livia dies Tony watches that film on TV. Obviously, Junior's pie in his mistress's face (I, 9) echoes Tom Powers' (James Cagney) grapefruit in his Kitty's (Mae Clark). But where Tom's action characterizes his misogyny Junior's marks his own denial of his sensitivity and generosity. And though the Irish-American of the 1930s cops and robbers film gives way to the Italian-American, some of the most dramatic scenes in both works happen over dinner. But of course, the classic film's relevance to *The Sopranos* runs deeper than those obvious citations. Wellman's film focuses on the rise and fall of a Chicago hoodlum in the early 20th Century. As a boy Tom plays tough guy. He accepts his policeman's father strapping with stoic disdain. He ridicules his older brother Mike's (Donald Cook) virtues: a legitimate job on the streetcars, night school study to improve himself, volunteering for the marines. Mike's virtuous romance with Molly Doyle (Rita Flynn) contrasts with Tom's leading her brother Matt (Edward Woods) into crime.

Tom anticipates the Sopranos' life of illicit and excessive pleasure. After the introductory Chicago montage the first scene establishes the Wellman film's ethos. A man toting six pails of beer crosses paths with a Salvation Army band, parading in the opposite direction. It passes a bar, from which young Tom and Matt emerge with a pail of beer, presumably to deliver. Tom's heady swig leaves him with a beer foam, not milk, moustache. To the band's "Brighten the corner where you are," at that corner two forms of life-brightening collide: the Sally Ann's religious and community values vs. Tom's precocious choice of criminal hedonism.

With the advent of prohibition the Salvation Army's values may seem to have won. But the ban only nourishes the underworld's growth to provide the forbidden pleasures. The sophisticated society stocks up on booze on the eve of prohibition, as a florist empties his truck for booze and a family wheels a baby stroller full of bottles. Like the lordly businessman

Lehman's furtive deal with the hoodlums to reopen his brewery, these images confirm the futility of prohibition, given the weakness of the flesh for the flash. Tom's self-indulgence anticipates the Sopranos', as it brings him the genre's conventional fancy clothes and cars, bubbly night life, and a fancier mistress, Gwen Allen (Jean Harlow).

That may seem preferable to the depression that the shell-shocked Mike brings back with his medals from the war. Nonetheless, opening and closing titles identify Tom as a social problem that the public must address. This confronts the charge—familiar to *The Sopranos*—that the film glorifies the hoodlum. Like Gandolfini's Tony, though. Cagney's charm and his character's constant screen presence are solid counterweights to his folly and his doom. Like Tony, Tom feels himself a loner, responsible to none but himself, who thinks he can buy off his family's shame.

Brother Mike's ethic is to serve others. As a boy he saves Molly from Tom's stolen skates. He goes to war out of responsibility to his society and urges Tom to stay home, to take care of their mother. No wus, Mike knocks Tom down for suggesting he steals from the bus company, then again to reject Tom's blood money. Tellingly, no such selfless character can be found among the Sopranos. But Mike is somewhat echoed by Charmaine Bucco and by Melfi's mentor, Dr. Kracauer. Mike's rejection of Tom's dirty money – "That money is blood money and we want no part of it"—anticipates Dr. Kracauer's advice that Carmela fails to sustain when she returns to her marriage and rationalizes away her failure by donating to her daughter's university.

Tom also evinces the womanizer's disdain for women – in the spirit of the Bada Bing! – not just in the famous grapefruit scene, but when earlier he excuses his trick on Molly: "What do you care? She's only a girl." This anticipates the Sopranos' fear of the feminine, of softness. Initially the slick hood Samuel Nathan (Leslie Fenton) seems nicknamed "Nails" because of his elegance, but his nightclub remarks about the villainous Putty Nose (Murray Kinnell) – "The guy's going to get you again. He thinks you're soft."—rather suggest he is as hard as nails.

After Putty Nose's betrayal, Tom and Matt are adopted by a more honorable mentor, the barkeep Paddy Ryan (Robert Emmett O'Connor), who gives them advice, then brings them

into his lucrative bootleg operation. Like the Sopranos' *omerta*, Paddy gives Tom an ethic and a fraternity that his harsh policeman father failed to impose. From Ryan enlisting Tom and Matt, Wellman cuts to the home scene where Tom finds his mother crying but proud that Mike is going off to serve his country at war.

Like *The Sopranos'* investigation of manliness and homophobia, in the film the male bonding extends into implications of homophilia. To avenge their boyhood betrayal by Putty Nose, Tom pulls Matt away from his rival Mamie (Joan Blondell) on their wedding night. Framed low between the newlyweds, Tom interrupts their kiss. As a boy Tom calls Matt away from his pursuit of a girl.

Moreover, their friendship is depicted as Tom's denial of Matt. Tom tells Putty Nose "I'm always alone when I'm with Matt." That joke he repeats at the nightclub: ""I'm alone, but Tom's all fixed up. He's with me." After they pick up the two girls, Tom tells Matt "I don't even know you're here." Later he tells Gwen that Matt "ain't got a name, just a number." Like his proprietorial defense against women, denying Matt seems to be Tom's cover for his emotions, possibly love.

The film anticipates the TV series' concern with the criteria for manhood. As in the "making" of Christopher, Putty Nose hands the boys their first guns as a rite of manhood: "Ya gotta grow up sometime." Hence the Soprano men's vulnerability to their soft side, too, the suspicions about Tony's therapy, and the inevitably untrustworthy nature of Pussy.

Like the Old School *Sopranos* the thieves have their own honour. Paddy's code operates not within the law but with the values of the underworld: "There's only two kinds of people: right and wrong. Now I think you're right. You'll find I am – unless you cross me." In a parody of this ostensible straight shooting, Paddy and Tom hit the spittoon every time. But shooting outside the law cannot be straight, however sympathetic the criminal. In Paddy's (under)world the good are loyal not legal.

Like the Sopranos,' Ryan's code opposes both the police and rival gangs. Ryan initially teaches the two boys the value of friendship: "I may need a friend myself someday.... Nobody can do much without somebody else.... You've got to have friends." When Paddy gathers all his cohorts' money and guns and locks them in an apartment—"going to the mattresses," in *Godfather*

parlance—we suspect betrayal. Yet Tom betrays Paddy when he in a drunken stupor is seduced by Paddy's girl, Jane (Mia Marvin). Paddy ultimately offers to leave town in return for Tommy's safe return.

When Tom realizes he betrayed Ryan he slaps the girl and storms out of the gang's refuge. That flight leads to Matt's death, for Matt follows him, as usual: "Why'd you want to run out on me for? We're together, ain't we?" "Sure," Tom says, with that affectionate punch on the jaw that he hasn't granted Matt since he killed Putty Nose. That proves Matt's kiss of death. Out on the street Matt is killed, but Tom escapes. Smiling in resolve, he takes on the enemy gang by himself, emerging into the rainy night wounded. After a life of denying his emotions, his remorse at betraying Paddy and his final admission of feeling for Matt lead to Tom's downfall as a criminal and his redemption as a human being.

What impels Tommy's reform is knowing he betrayed his friend Paddy and caused Matt's death. Perhaps the film's central theme is the false manliness Tommy has imposed upon Matt – first imaged in the lad's beer-head moustache. The wounded Tom's admission, "I ain't so tough," refers both to his physical wounds and his repressed feelings for Matt.

This Public Enemy has discovered private feelings, after all, though he has fancied himself too tough to allow them. From his hospital bed he finally apologizes to Mike and admits his filial failure to his long suffering mother (Beryl Mercer). "Tommy boy, you're my baby" she assures him. Given the recovery of the brothers' friendship and the reuniting of the family, Tommy's apparent reform makes his mother "almost glad this [near-fatal wounding of Tommy] happened." In response Tom softly punches her head.

That playful punch is Tom's most characteristic, indeed only, expression of affection. That's how he expresses affection to his mother, to the nightclub *maitre-d'*, to his pickups, and ultimately to his beloved Matt. Tom's only emotional expression is a softened form of violent aggression. Similarly, Tony expresses his affection only by lavishing his ill-gotten luxuries. But Tony and Paulie had therapy to free their emotional expression.

Still, to his mother Tommy remains "just a baby," so he shouldn't enlist. Mike declares him "the man in the family now," not for his gun but for his new familial responsibility. Like Tony's,

Tom's charm is defined as a boyishness. Gwen is finally ready to accept him as a lover when she declares him "a spoiled boy.... My bashful boy," who is different from the "dozens" of other men in her life: "You don't give, you take. I could love you to death." So too Ryan's girl, Jane: "I want to do things for you, Tommy. You don't think I'm old, do you, Tommy? You like me, don't you, Tommy?... Just a good night kiss, for a fine boy." In this spirit, Dr. Melfi, Gloria and Ralphie's ex are attracted to Tony's bad-boy charm, as both Gwen and Jane cuddle Tom.

Tom's otherwise suppressed charm and innocence also lie behind his mother's unquestioning love. She blames a young colleague's death on his falling in "with the wrong kind of people," *i.e.*, her own son, Tom. She remains blind to his guilt and faults. Early her singing stops and she sighs helpless at her son's punishment. In the film's climax, she sings in joy that her "baby" is about to come home to her, as she freshens the linens in his old bedroom. But Tom is delivered dead, like Frankenstein's monster, trussed and stiff, and he falls forward on his face at the front door.

When Tony watches Ma Powers lovingly prepare for her son's return she amplifies his own sense of how remote his mother's feelings were for him. The dead son's return reflects Tony feeling deadened by his relationship to his just dead mother. The classic gangster film offers an ideal mother that the "real" gangster has missed. Here *Public Enemy*'s pertinence to *The Sopranos* is indirect, a matter of reversal.

Similarly, when Nails Nathan is fatally thrown from his horse, Rajah, Tom buys the horse for a grand and shoots him. This is antithetical to Tony's commitment to Pie-O-My and his avenging her death. In this spirit, too, Tony's casual sport shirts and slacks reject the posh style that the genre gunsels immediately adopt to emblematize their fast wealth.

The Sopranos also draws on *Public Enemy* in incidental ways. The wintry extreme through which Tony staggers home to Carmela (V, 13) recalls the dense downpour in which Tom avenges Matt. In both these scenes of "pathetic fallacy," the weather is an image of the character's emotional or psychological state. Anticipating Tony's defence of his "soldiers," Tom turns upon the disturbed veteran Mike: "Your hands ain't so clean. You've killed and liked it." When Matt blames Putty Nose for turning the boys toward crime Tom rejects the excuse: "Yeah,

we might've been ding dings on the streetcar" – like his brother Mike. Tony like Tom claims his life and nature would allow no other career. When Tom is kidnapped from his hospital bed, Mike's violent rage to avenge him – cooled by the savvy Paddy Ryan—anticipates Artie Bucco's characteristic anger and impotence.

 Of course, nothing in *The Sopranos* requires a detailed knowledge of *Public Enemy*. However, the pointed allusions to the film invite this fuller consideration both of Wellman's construction and of the myriad ways it deepens David Chase's work. Certainly the older film's general claim to present not an individual psychotic but a social problem that "society" needs to address equally applies to the charming, culpable and ultimately symptomaticTony.

Appendix II

The Stereotype Problem in *The Sopranos*[2]

As a Jew and an academic I have some idea of the difficulty of living under a negative stereotype. And so I have considerable sympathy with the Italian-Canadian and Italian-American communities as they chafe under the immense popularity of *The Sopranos* and feel lashed yet once again by the reductive depiction of Italians as Mafiosi.

To that pain I could not presume to offer a rebuttal or a denial. You feel it therefore it is. What I would like to do is provide a closer analysis of that show's treatment of the Italian so that you might have a sharper sense of David Chase's undertaking – himself an Italian American – so that you can—if not enjoy the show—at least know that you have an alternative to feeling it abusive.

In my experience the people who are most offended by the show have not seen much of it – if indeed anything at all. That is understandable, given that pain is not usually one of our objectives in choosing an entertainment. So these critics cannot have a sense of the show's sophistication in its writing, direction, performance and overall effect, the unprecedented maturity and challenge it has brought to American television. I have no doubt that *The Sopranos* will survive as a major cultural icon of our times. In its poetry, circumspection and moral complexity this is the first television work to reveal both a Shakespearean ambition and a Shakespearean achievement. It stands with *Othello* and *The Merchant of Venice* as works that confront human bigotry and transcend the prejudices of their day in plumbing their problematic heroes' humanity.

I'll start with two generalities. First, not all the gangsters in this series are Italian. The show is Equal Opportunity satiric. There are Jewish gangsters, black gangsters, Puerto Rican gangsters, Colombian Native American gangsters, and there is even a healthy representation of WASP gangsters in highly respectable positions—in the church, in politics, in the law, in medicine. For the show's satire does not target

[2] This is an abbreviated recollection of my talk to the 20th anniversary meeting of the Association of Italian Canadian Writers, Vancouver, May 25, 2006. The proceedings were published in *Strange Peregrinations: Italian Canadian Literary Landscapes* (Toronto: Frank Iacobucci Centre for Italian Canadian Studies, 2007).

Italians but the general corrupt selfishness of our times. As Chase has said, his gangsters personify the excesses of our Me First generation. This is a highly moral work, which holds up a range of culpable figures, not for ethnic insult, but as a moral test of its viewers. As this show tempts us to accept Tony and Carmela's ostensibly principled corruption and the various codes by which they claim honour, the drama works the way W.H. Auden suggested a good book works. You don't read it; it reads you. This rich, dense drama provides a relentless test of its viewer's moral fortitude.

Of course, one of its recurring tests is our ability to resist ethnic stereotypy. When Tony bristles against his son's school's assumptions about the Italian gangster, he confronts the very subject of which the show often stands unfairly accused. The show does not exercise ethnic stereotypy but warns us against it. Hence the social pecking order Chase dramatizes between the Italian gangsters and the White Bread Italian doctors and lawyers, who are thrilled by Tony's lifestyle but won't let him into their club. Furio, from the South of Italy, condemns Italians from the North. For that matter, Tony himself continually vituperates other ethnicities, the Jews, the blacks, the Natives. The man who himself suffers from ethnic stereotypy indulges it at others' expense. Hence the energetic poetry of his attack upon Meadow's Jewish/Black boyfriend, Noah. Hence, too, Livia's and Uncle Junior's reflex assumptions about "the desert people," quite countermanded by Hesh's humanity and warmth and by their dependence upon lawyer Mink. Continually, Chase satirizes ethnic stereotypy and exposes its dangers and failings.

In the same vein, the show does not simply continue the Hollywood genre of Italian gangster films, but holds it to account. The characters explicitly style themselves after the *Godfather* trilogy, in their language, their rituals. Paulie's car-horn plays the Coppolla film's theme. The more these characters try to live the fiction they have been fed the more they fail as human beings. They think of themselves as *Godfather* characters, but they actually live the more sordid betrayals, debasement and delusions of Scorsese's *GoodFellas*, after which Chase models his use of music.

The second generality is that not all the show's Italians are gangsters. We meet very impressive Italian professionals and citizens alike. In fact, the show's moral center is probably – not Doctor Melfi, whose modernity and nonjudgmental liberalism make her rather too much like the ennabling Carmela – but an Old School Jewish therapist, Dr. Krakauer (III,7), and Artie Bucco's wife, Charmaine. Both see through Tony's serpentine charm and refuse to be contaminated by his

money. The gravity of their firm example balances out the various charms and fascination that evil, here as in *Paradise Lost*, holds. We also meet a good many helpless Italians who are themselves victimized by the Mob.

In fact, David Chase goes to great lengths to praise the Italian American community and values. Tony himself eulogizes his forefathers' contribution to the building of America, his community's magnificent contribution to the nation's effort in WW II, the culture's astonishing contributions to world culture, from the godhead Sinatra to Meadow's "Mario Lasagna" to Maiucci, the true inventor of the telephone. Indeed, though at the most the Mafia Italians may have numbered 5,000, it is an unconscionable slur to hold them characteristic of America's community of twenty million Italians. And where did I pick up that useful bit of data? *The Sopranos*.

Where the show's Italians are at their worst they are but emblems of a broader human failing. In their villainy they are amply balanced by those of other ethnicities. It is at their best that the Italians here are distinguished from their surrounding society. No other culture is as positively characterized here as the Italians, sometimes comic as in Paulie's indignation at his culture's coffee having been hijacked by Starbucks, more often serious, as in Tony's articulation of his forefathers' values in the face of contemporary – and especially his – decay. The Italian family is celebrated for its closeness, its passions, its cuisine, to the point that for at least this – not entirely unrepresentative viewer – the effect is rather jealousy than any sense of superiority. Once we set aside the criminality that Tony shares with his rainbow coalition this drama makes one want to be Italian. For my part, I can only study one or two episodes before I'm driven to Calgary's Lina's for a canolli. That should not embarrass you – and neither should this brilliant epic drama.

Appendix III

The Godfather's Oranges

The recurrence of oranges in Francis Ford Coppola's *Godfather* trilogy has prompted some speculation, with the simplistic conclusion that the orange is a symbol of death. [3] The problem with that reading is that there is no clear connection between an orange and death. No-one in the trilogy dies from, say, a poisoned orange or the paralysis of Navel gazing. Instead, oranges recur in such a wide range of contexts that they form a pattern of associations rather than one fixed meaning. The image collects various connotations from its different contexts and from the trilogy overall.

As oranges appear at the beginnings and the ends of the godfathers' careers, perhaps the pattern portrays the Corleone family's loss of innocence and moral health. When soldier Michael (Al Pacino) ceases to be a "civilian" and he hardens and he kills, he expands the Family empire—at the cost of his family and his soul. The oranges bring a flash of brightness and colour to the gangsters' gathering darkness.

Two other contexts are possible. The Corleone orange could be considered an antithesis to New York's Big Apple, i.e., the Sicilian immigrants' (*inter alia*) dream. Or it might be a more modern version of the apple in Eden, which signifies the loss of original grace and the bitter fruit of forbidden experience. As Andy Griffin has suggested on the Internet, the Sicilian orange would be the red blood orange instead of the anonymous domestic we see.[4] Coppola's orange is orange, itself bloodless because in his trilogy it witnesses and becomes a stand-in for the bloodshed that characterizes the business, political and church institutions that the Mafia reflects upon in the three respective films.

Two scenes establish the initial importance of the orange. In the first, just before the failed attempt on his life, Don Vito (Marlon Brando) buys some oranges. When he falls the fruit spills on the street like his blood. After Alfredo (John Cazale) visits Vito in the hospital, the

[3] For an extensive but not always reliable – whose is? -- list of the oranges in the trilogy see www.jgeoff.com/godfather/oranges.html

[4] **www.mariquita.com**

oranges next to him recall his helplessness during the attack. The second is at Vito's death. After grandson Anthony playfully squirts pesticide at him (itself a chilling irony), Vito scares him by flashing orange-wedge fangs. That game contrasts the old godfather's murderous Family past to his family bliss, as he enjoys his grandson amid his traditional tomatoes. In *Godfather III* Don Altobello (Eli Wallach) will speak of idyllic retirement to his tomato patch. These scenes' association of the orange with death and violence deepens the impact of the fruit's and the colour's more incidental appearances.

The first orange is the one that Tessio (Abe Vigoda) plays with at Connie's wedding in *Godfather I*. In the prequel we learn that Tessio was, with Clemenza, Don Vito's earliest colleague in crime. At the end of *Godfather I* Michael will have Tesseo killed for betraying him to Don Barzini (Richard Conte). "Tell Michael it was only business," Tessio asks Tom Hagen (Robert Duvall) to intercede, "I always liked him." The early orange foreshadows Tessio's betrayal and death, with the added inflection of his casualness with it.

In various scenes of meetings, the oranges in the fruit bowls suggest the sinister issues being negotiated in the various power struggles. On the marital battlefield, at Connie's wedding there are oranges in front of Sandra (Julie Gregg) when she jokes with the girls about husband Sonny's (James Caan) penis size – which he is at the time applying to a bridesmaid. More officially, the bowl of oranges on the table separates Tom Hagen and Hollywood producer Woltz (John Marley), when the latter explains why he won't give Johnny Fontane (Al Martino) his career-making film role. As in Eden, Woltz considers Fontane the snake in the grass for seducing the starlet Woltz discovered. She was young, beautiful, talented, innocent – and "the best piece of ass I ever had and I had it all over the world." Here the orange suggests the corruption of innocence especially where there is the false pretense to prize it.

At the Families conference where Don Vito realizes that Barzini is the true force behind his enemy Tattaglia (Tony Giorgio), there are prominent oranges in the bowls in front of those two, with walnuts and green grapes in front of Vito. The contrast underlines their conspiracy against him. The shot emphasizes Tattaglia's oranges when Vito promises peace with him.

Of course, orange is a colour as well as a fruit. Luca Brasi (Lenny Montana) is sent to "sleep with the fishes" in a bar with fish decorations and orange walls. The decor heightens the omens. More often, though, where the fruit emblematizes the gangsters' deadliness,

the colour tends to be associated with outsiders. At Connie's wedding we see the band members' orange bands when Johnny Fontane sings and the detached Michael tells Kay (Diane Keaton) about Vito's "offer he couldn't refuse." At Anthony's baptism the clergy's orange raiment is as deceptive as the uniformed "cop" that kills Barzini.

Kay's orange dress and hat-ribbon at Connie's wedding work like Michael's paradoxical soldier suit, when both are "civilians," outsiders in the Corleones' criminal world. Indeed, Michael insists on including Kay in the family photograph because she represents his determination to stay out of his family's way of life. At this point his family "is not me." Still an outsider, Kay wears an orange coat and hat when she asks Tom to relay a message to Michael, hard upon his Sicilian marriage, in which he recreates himself as his father's Sicilian son. When he returns to Kay a year after returning from Sicily, three of her pupils wear orange caps. He still wants her to signify his promised legitimacy. The Corleones move to Nevada in an orange van. Unfortunately for Michael, Kay's legitimizing of the colour will fade before Michael's violence and emotional hardening. This begins when he lies to her face about his having Carlo killed and when he closes his door against her in *Godfather I* and banishes her in *Godfather* II.

An unseen orange early in *Godfather II* bridges the films as explicitly as the opening shot of Michael receiving the gangsters' homage. The treacherous Johnny Ola (Dominic Chianese), who will turn Alfredo against Michael, brings Michael "an orange from Miami." That Ola *is* the threat to Michael is suggested in his orange leisure suit and hat. The fruit again appears in the bowls at the Cuban meeting of American "businessmen" before they carve Cuba up among them like Hyman Roth's (Lee Strasberg) Cuba-shaped birthday cake.

In *Godfather II* perhaps the orange's most important involvement is in the flashback to Vito's usurping of Don Fanucci's (Gaston Moschin) power. When Vito (Robert de Niro) first challenges Don Fanucci by reducing his protection price, Vito passes an orange stand. He is as heedless of the fruit as he is of where this first gutsy step will lead him. When Don Fanucci leaves Vito, he steals an orange *en route* to the religious procession, conjoining his corruption and religiosity. After Vito kills him, the first sign of his new power is the vendor's refusal to accept payment for his bag of oranges. These prequel oranges retrospectively foreshadow both the attempt on Vito's life and his death.

So, too, the contrasting fruit that anticipates Vito's happy death among his tomatoes. After losing his grocery job to Don Fanucci's

nephew, Vito brings his wife the luxury gift of – a pear. The homonymous pear/pair confirms Vito's fidelity, as he tells his friend at the theatre that his love for wife and family precludes any notice of any other beauty. This non-orange becomes an emblem of the innocence Vito is about to lose as he assumes the Don's corrupting power. Given this luxury fruit, the rich fruit bowl also comes to signify the immigrant's sense of bounty in America. The meeting scene fruit bowls become a more natural alternative to the tray of gift jewelry passed around.

Vito's orange gift appears right after Michael's touching scene with his mother, where he asks her if it is possible for him to lose his family through his very attempt to strengthen it. As Coppolla intercuts Vito's beginnings with Michael's advancement of his f/Family business, Vito's community service, modesty and building of his family contrast to Michael's deepening corruption and chilling of his family bonds. Michael picks up an orange as he prepares to kill his false partner Hyman Roth: "He's been dying of the same heart attack for 20 years." The orange's collected values align Michael's heart-hardening to Roth's. Michael peels and eats the orange as he plots Roth's death. He recalls the attack on his own father: "If history has taught us anything, it says you can kill anyone."

The oranges in *Godfather III* continue to represent a nature but now also a church turned sinister. They recur in business scenes. As they appear in the fruit bowls at the Commission meeting, Joey Zaza's (Joe Mantegna) helicopter attack is announced when an orange ominously rolls to the floor. Oranges appear at the end of the massacre on the shot-up table and in the ensuing kitchen discussion, where Michael's diabetic stroke sends him to the hospital in an orange-walled ambulance. There are orange stained-glass windows in the chapel where Connie and Al Neri (Richard Bright) approve Vinny's (Andy Garcia) plan to kill Zaza. Convalescing Michael wears orange and black striped pyjamas when he scolds them for having countermanded his wishes. There is orange juice at breakfast when Michael signs legitimate papers and remarks that Vito hated foundations, favouring personal service over the institutional.

When the Corleones' oldest friend and covert enemy Don Altobello (Ely Wallach) counsels Michael's retirement there are orange flowers between them and he wears an orange scarf. The glass of orange juice Neri puts between the two evokes Altobello's initial hypocrisy, when he added his million dollar donation to Michael's foundation and pretended to have lost "all the venom, all the juice of youth." When he contracts Mosca (Mario Donatone) to kill Michael, Altobello tosses an

orange to the peasant's braying son. Altobello's venomous juice is intact to the end, when an orange-hatted Connie gives him poisoned cannole.

Orange still resonates in the décor. Mary (Sofia Coppola) drives her orange convertible to Vinny's club, which has orange broadloom in the hallway. In Sicily orange and green banners welcome Michael, orange chips brighten the poker table between Vinny and Mary, and Don Tomassino's (Vittorio Duse) villa abounds with orange flowers. When Vinny pretends to join Altobello there are orange flowers behind them.

Just before Mosca kills Don Tommassino, an unknown priest on a bicycle hands Kay an orange bouquet. There are oranges behind Kay when Tommasino is reported dead ("It never ends," she regrets.). Orange flowers appear behind Tommasino's casket when Michael swears "on the lives of my children, give me a chance to redeem myself and I will sin no more." Michael immediately breaks that oath, sanctioning Vinny's attack on their enemies, with orange candles and an orange-backed chair between the two men. The colour presides over both Michael's damnation and his passing of the Corleone name and authority to Vinny.

Conversely, the virtuous, true priest, Cardinal Lamberto (Raf Vallone), wears an orange skullcap and sash when he hears Michael's confession in the garden where he hears his priests'. This follows Michael's diabetes attack, when he restores his blood sugar with orange juice. As Michael cannot accept his redemption, that juice suggests that he has so corrupted himself that evil has become his lifeblood. When the cardinals wear orange to elect Cardinal Lamberto pope, the church itself accrues the fruit's ambivalence and corruption.

So, too, the theatre which replaces the church settings with which the climactic murders were intercut in the first two films. The stage curtains where Anthony triumphs and the outside stairs were Mary is killed are orange, making both stages for tragedies. Earlier, when Michael sneaks away to show Kay his Sicily, they pass a church wedding with orange carpet on the outside steps and a puppet theatre where, against an orange backdrop, a father kills his daughter on a point of honour. Kay recognizes the Sicilian way.

As befits this swelling pattern of images, the orange that attends Michael's death contrasts his death – and his life – to his father's. Where Vito dies happily among his tomatoes, playing with his orange and his grandson, Michael dies cold and alone in an empty courtyard. Michael seems to have drained the Tommasino estate—that once abounded with orange flowers—of life, hope and colour. As the long

shot reduces the erstwhile power into a small silhouette at dusk, a dark orange falls from his hand, he slumps, then falls from his chair, dying with – and by Zaza's implication like—a dog. This last orange rhymes with the rolling orange that heralded Zaza's attack. It provides a summary conclusion to the immigrant Vito's dream of his dynasty amid America's plenty and Michael's sacrifice to its brutalizing power.

In *Godfather III* one's limiting "nature" becomes a theme. Joey Zaza says that cutting "a *bella figura*" is "my nature." Michael at first excuses Vinnie's hot headedness as "your nature." Where Tom Hagen's son and Anthony affirm a nature outside their background – becoming a priest and an opera singer, respectively – Michael abandoned his hope for an independent destiny. As he explains to Kay, he had no choice but to protect his father and then to protect his family – by rising to the (Milton's) "bad eminence" of the underworld. As he notes here, "The higher I go the crookeder it becomes," indeed into the highest echelons of the Vatican. But Michael cannot evade his responsibility for for his choice, for his particular "nature."

Perhaps across the trilogy the orange colour comments on the fruit's association with nature. Its shifting meaning shows an ambivalent nature. As an emblem of natural health and brightness, it contrasts to the unnatural corruption both in the Corleone empire and in its surrounding social institutions, first in the business world, then in politics, and ultimately in the church.

The Vatican's partner, Don Lucchesi (Enzo Robutti), takes the cynical stance: "He who builds on the people builds on mud." The fertility of the orange represents the more positive view of humanity, service to which lets the poisoned new pope Lamberto die with a smile on his face. The orange becomes an emblem of even the damned Michael's spiritual possibility. As Cardinal Lamberto tells him, "Your life will be redeemed. But I know you don't believe that. You will not change." When Lamberto grants him absolution the jug of orange juice appears behind him. That is, Michael turns his back on his life saver.

Of course, the fruit itself remains salutary and innocent even as it collects negative associations from the characters' and the institutions' corruption. In sum, the orange represents nature's, America's and the citizen's bounteous potential, especially when it attends the violence and greed where the characters fail their potential nature

Printed in Great Britain by
Amazon.co.uk, Ltd.,
Marston Gate.